CLEVELAND
AREA GOLF

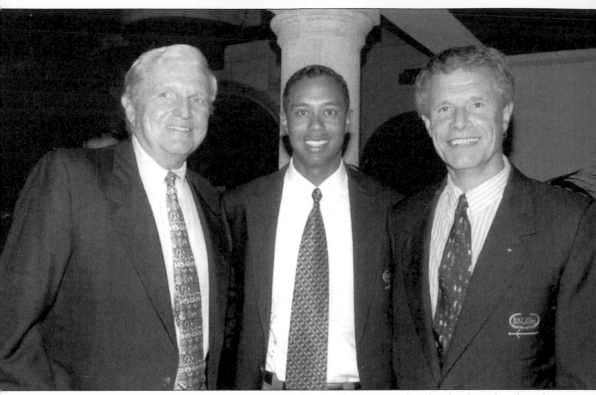

SPORTS MANAGEMENT. Mark H. McCormack started IMG in Cleveland. Their first big client was Arnold Palmer, who is still their client and has maintained that relationship through the years with only a handshake agreement. IMG started about 1960 and became a large international operation. They market sports packages that can include players, sponsors, television, and films. They are worldwide and unique in the world.

Mr. McCormack died in 2003 and Alastair Johnston became a co-CEO to lead IMG into the future. Incidentally, Mr. Johnston has the largest golf book collection in the world. Their newest, brightest client is Tiger Woods. Tiger has had a phenomenal career, winning 40 PGA Tour events, including 8 majors, since becoming a professional in late 1996. The photo above shows, from left to right, Mark McCormack, Tiger Woods, and Alastair Johnston. (Courtesy of IMG.)

CLEVELAND AREA GOLF

*To Mike
from Dad*

Ken Hopkins

Kenneth L. Hopkins

ARCADIA

Published by Arcadia Publishing
Charleston SC, Chicago IL, Portsmouth NH, San Francisco CA

Printed in Great Britain

Library of Congress Catalog Card Number: 2004113055

For all general information contact Arcadia Publishing at:
Telephone 843-853-2070
Fax 843-853-0044
E-mail sales@arcadiapublishing.com
For customer service and orders:
Toll-Free 1-888-313-2665

Visit us on the internet at http://www.arcadiapublishing.com

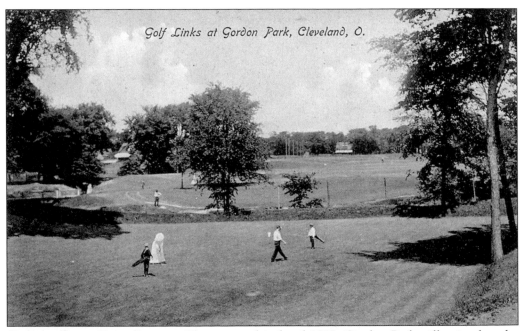

GORDON PARK GOLF COURSE. This postcard is dated 1908. Gordon Park still exists but the golf course does not. It was a nine-hole public course, probably opened shortly prior to 1900, making it one of the earliest courses in Cleveland. Bert Way says it already existed when he designed the Euclid Club in 1900. (Courtesy of the Marjorie Meltzer Collection.)

CONTENTS

Dedication

This book is dedicated to all those players,
Past and present, who
Walked the golf courses of Northeast Ohio
And elsewhere; who
Smelled the fresh mown grass, who
Breathed the cool morning air; who
Thrilled at a crisp iron that
Flew off the face of the club, and
Soared straight for the pin; who
Sometimes hit a drive, so sweet,
It was long, with a little bend
At the end to match the fairway's curve; who
Occasionally sank that long curling putt, or
Even a short 5-footer to win the match; who
Remember a few career shots—a hole-in-one,
A perfect recovery; who
See the course as a beautiful place, and
Even thank God for the experience of golf; who
Play by the rules and
Are ever kind to fellow competitors; who
Share their thoughts about the game,
After the round, in the clubhouse, about
This game of golf, that's a part of our lives.

—Kenneth Lowell Hopkins

ACKNOWLEDGMENTS

My wife Martha has done all the typing of the text and helped in editing the contents. She also accompanied me on most of my data gathering trips. I could not have completed this book without her help. She has my eternal gratitude.

Bob Wharton, director of the Northern Ohio Golf Association, has been especially kind to allow me access to their archives, and it has been a very helpful resource.

Marjorie Meltzer, a fellow member of the Golf Collector's Society, has shared many items with me that I have used in the book. She and her husband, Max, have been very hospitable to us.

Richard Mellott, member of Spring Valley Country Club and retired dean of the Lorain County Community College, also shared several items used in the book.

The following list of others who have been very helpful is in no particular order, but my thanks go to each:

Ken Stofer, Brian Pizzimenti, Choppy Sage, Lakewood C.C.
Robert Josey and Jack McKelvey, The Country Club
Alastair Johnston, IMG
Sun Newspapers
Ernie Mansour
Mark Gore, Firestone C.C.
Dan Denihan and Mike Hardy, Canterbury G.C.
Jim Callihan, Elyria C.C.
Dave Smith and Mike Azbill, Mayfield C.C.
Gary N. Mazzeo, Grantwood G.C.
Rich Thomas, Giant Eagle LPGA Classic
Don Gleichauf, member Columbia Hills C.C.
John Fraylick
D. Frank Dobie, The Sharon Golf Club
Philip Boova, Shaker Heights C.C.
William Downey and Carol Hamilton, Beechmont C.C.
Luci Schey, Cleveland Women's Golf Association
Melvin C. Grills, Westwood C.C.
Bill Martz, Lake Forest C.C.
Gary Trivisonno, Aurora C.C.
Dennis Romanini, Tanglewood C.C.
Greg Winger, Spring Valley C.C.
Claudia Caviglia, Oakwood C.C.
Mary Ann Bierman

INTRODUCTION

Northeast Ohio is home to about 230 golf courses, including 49 private golf clubs that belong to the Northern Ohio Golf Association, the USGA regional affiliate. Golf was first played in the area about 1895. The Country Club of Cleveland and Akron's Portage Country Club played an inter-club match in 1896. The first 18-hole golf course may have been the old Euclid Club, which was opened for play in 1901 and only existed until about 1915. However, the Euclid Club had a spectacular life during its short years, hosting several significant tournaments, including the 1907 U.S. Amateur Championship.

Bert Way came from Detroit to layout the Euclid Club in 1900 and he later stated, "at that time there existed in the Cleveland district the Dover Bay Club, Westside Golf and Cricket Club on Detroit Avenue, The Country Club [9 holes] in Bratenahl, and the nine-hole public course in Gordon Park." None of these are still around except The Country Club, and it is in a different location; however, the changes are due to urban expansion. A fervor for golf existed in its infancy in Cleveland and Northeast Ohio and it still exists today. Golf activity rises and falls somewhat with the economy, but the true golfer finds a way to play. That may mean nine holes at dawn before going to work, or perhaps practicing chip shots in the backyard in the evening.

Anyway, over the last 110 years or so, golfers in Northeast Ohio have been founding courses and clubs, holding tournaments, and seeking the fulfillment of their golf desires. The area has produced some of the best golfers in the world, Denny Shute and Tom Weiskopf, for example. Area courses have hosted four PGA Championships, two U.S. Opens, four U.S. Amateurs, two U.S. Amateur Public Links, and many other national and regional tournaments. But perhaps the greatest contribution to golf by Northeast Ohio was the invention of the wound golf ball by Coburn Haskell in 1898.

Many of the early golf professionals came here from Scotland, such as Grange Alves, brothers Bert and Jack Way, and brothers Joe and Walter Mitchell.

Northeast Ohio has also benefited from some of the best architects in history: Donald Ross, A.W. Tillinghast, Herbert Strong, William Flynn, C.H. Alison/H. S. Colt, and Stanley Thompson. Modern architects have designed courses in the area as well, including Pete Dye, Jack Nicklaus, Tom Fazio, Robert Trent Jones, Hurdzan/Fry, Von Hagge, and Weiskopf/Moorish.

Nearly all of the famous golfers have trod the fairways in Northeast Ohio, including Harry Vardon and Ted Ray, Walter Hagen and Bob Jones, Lawson Little and Ralph Guldahl, Gene Sarazen and Joyce Wethered, Ben Hogan and Sam Snead, Arnold Palmer, Jack Nicklaus and Gary Player, and Tiger Woods and Phil Mickelson.

This book tries to highlight these events and we hope you enjoy the pictures and the words that tell the story of golf in Northeast Ohio. No doubt we have missed some things and left out one of your favorite golf courses, but it was not possible to include the full story of 230 golfing places and all that has happened in this great area over the past century-plus. May God bless you!

ONE

Golf Begins in Northeast Ohio

The Country Club—The Haskell Ball—The Euclid Club—John D. Rockefeller and Golf—Oberlin Country Club—Westwood-Dover Bay and Keswick—Elyria Country Club—Oakwood Club and the 1921 Western Open—Mayfield Country Club—Shaker Heights Country Club—The Van Sweringen Brothers Connection—Golf Architects in Northeastern Ohio

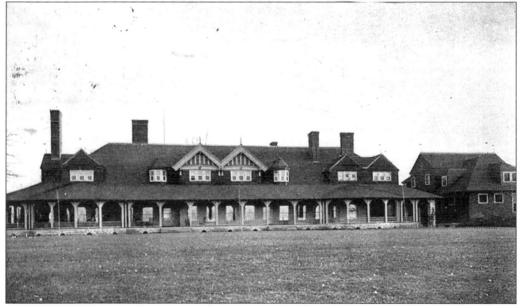

THE COUNTRY CLUB. This is the oldest golf club in Northeast Ohio, organized in 1889. It was originally located in the Glenville district and at first was just a country place for picnics and parties. Golf was not introduced until 1895, when the members designed an initial nine-hole layout. Samuel Mather had visited the St. Andrews golf course in Yonkers, New York, while on a business trip. He brought the game back to The Country Club. Shown here is the clubhouse that was built in 1900 to replace the original building, which was destroyed by fire in 1899. Subsequently, this clubhouse burned in 1906. (Courtesy of the Marjorie Meltzer Collection.)

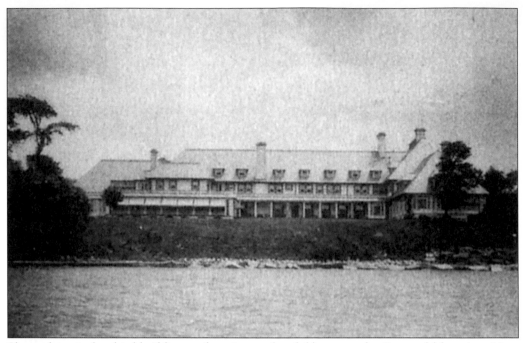

Shown here is the third building to function as the clubhouse at the Bratenahl location. Note the nearness to Lake Erie. (Postcard courtesy of the Marjorie Meltzer Collection.)

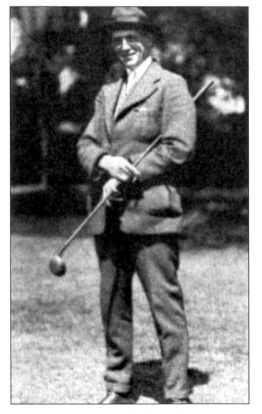

Joe Mitchell was hired in 1898 to be the golf professional at The Country Club and did greenkeeper duties as well. Unfortunately, the fire of 1899 destroyed all his equipment. Mitchell also had a role in the development of the Haskell ball. It seems that Haskell asked Mitchell to test the new ball. Harry Vardon played the course in 1900, against Mitchell and Sterling Beckwith. Vardon played four times around the nine-hole course in 37-33-35-38. The 33 set the course record. Joe Mitchell is also the one who taught John D. Rockefeller how to play. (Photo courtesy of The Country Club.)

The course expanded to 18 holes in 1914. After the club moved from Bratenahl to Pepper Pike in 1929, part of the course remained in use for several years, as part of Lake Shore Golf Club. (Lake Shore score card courtesy of the Marjorie Meltzer Collection.)

The move to Pepper Pike was facilitated by an offer from the Van Sweringen brothers, who were developing the Pepper Pike community. The Van Sweringens provided the land with reasonable payments. William Flynn designed the course and Phillip Small, a member, designed the clubhouse. Both opened in 1930. (Photo courtesy of The Country Club.)

LAKE SHORE GOLF CLUB
LAKE SHORE BOULEVARD AT EDDY ROAD
BRATENAHL, OHIO
GLENVILLE 3333

Greens Fee Rates

MONDAY to FRIDAY
60c before 3:30 P. M. 45c after 3:30 P. M.

SATURDAYS
75c until 12:00 noon 95c Bet. 12 - 3:30 P. M.
70c after 3:30
$1.25 All Day

SUNDAY AND HOLIDAYS
95c until 3:30 P. M. 70c after 0

Special Ladies Rates

CARL RAMSER, Manager
JOHN BEDECS, Greenskeeper

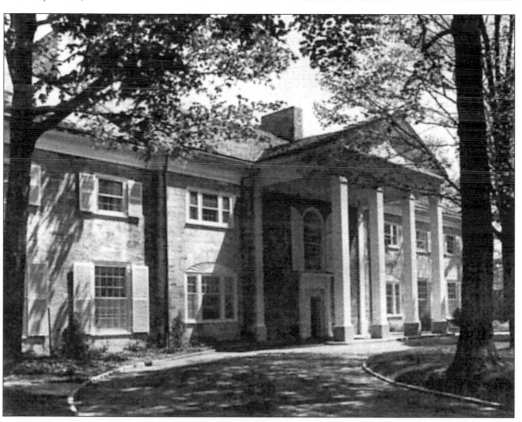

Billy Burke became the golf professional at The Country Club, in 1934, and remained there until 1962. He had a long and respected tenure. He won the Ohio Open in 1938, 1939, 1945, and 1955. (Photo courtesy of The Country Club.)

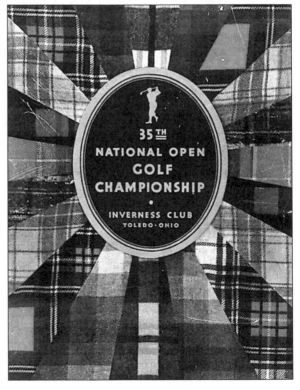

Billy Burke won the 1931 U.S. Open at Inverness in Toledo in the longest playoff in history. He beat George Von Elm after playing a total of 144 holes. The regulation 72 holes were tied. They then took two 36-hole playoffs to determine the winner. He also tied for sixth in the 1934 U.S. Open. He was a Ryder Cup team member in 1931 and 1933. Shown here is the cover of the 1931 U. S. Open program.

The Country Club had not hosted a national or international tournament after the 1935 U.S. Amateur until 1980, when it became the site of the inaugural World Series of Woman's Golf. This event was organized by IMG, the sports management company with headquarters in Cleveland. The top 12 professional women golfers were selected to play in this late season tournament. The 1980 winner was Beth Daniel. The cover of the 1980 program is shown. (Courtesy of The Country Club.)

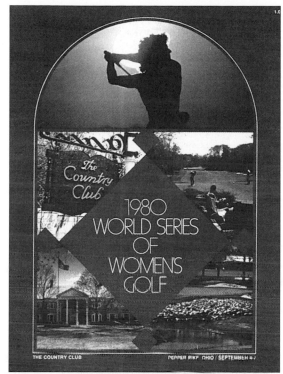

This author was fortunate to participate in the World Series of Women's Golf Pro-Am Tournament. Our foursome of amateurs played with Sally Little. Pictured here, from left to right, are Joe Callahan, Fred Lennon, Sally Little, Ken Hopkins, and Ernie Mansour.

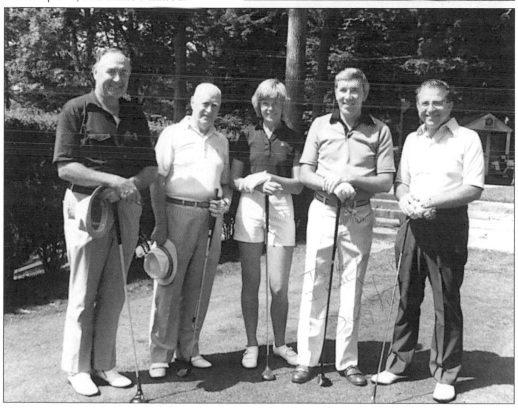

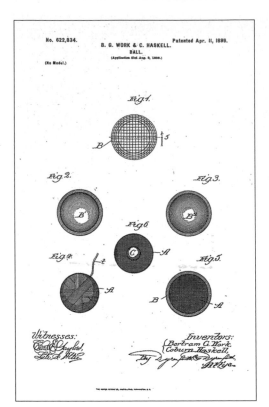

THE HASKELL BALL. One of Cleveland's claims to fame, golf-wise, was the invention of the Haskell Ball by Clevelander, Mr. Coburn Haskell, in 1898. The patent was issued April 11, 1899. It had a core of rubber thread windings with a gutta percha covering and replaced the solid gutta percha ball. Bertram Work of Akron and the B.F. Goodrich Co. worked with Mr. Haskell in developing and producing the new ball. The Haskell ball was lively and carried for more distance, but still could be putted without undue behavior. The patent drawing is shown at left.

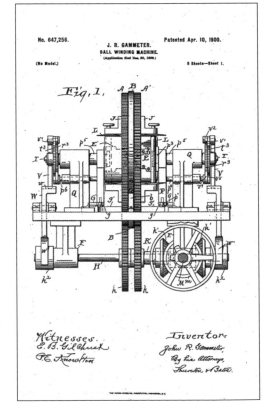

Mr. John Gammeter, master mechanic at B.F. Goodrich, designed a machine to produce the Haskell Ball, giving his company an advantage over competition in Great Britain. Golfers were fairly quick to switch to the new wound ball, and it was soon discovered that a bramble pattern enabled better control. Sandy Herd won the 1902 British Open using a single Haskell Ball all four rounds. Walter Travis reportedly won the U.S. Amateur with it in 1901. The patent drawing of the machine is shown at right.

There are various versions of how Mr. Haskell got the idea to make a wound rubber core ball. He was a member of The Country Club and played golf with Bertram Work of Akron who reportedly played at Portage Country Club. Evidently the idea arose between the two of them just before or after a round of golf. Coburn Haskell is pictured at right. (Photo courtesy of The Country Club.)

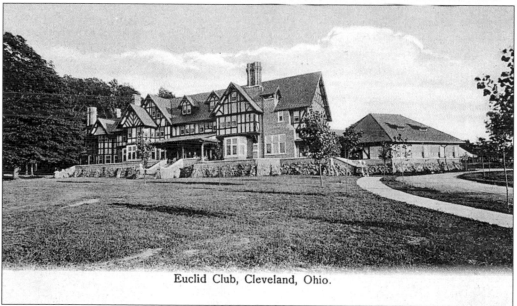

Euclid Club, Cleveland, Ohio.

THE EUCLID CLUB. This was the second golf course and club to be built in Cleveland, although other clubs nearby in Akron, Youngstown, Hartville and Oberlin already existed in the 1890s. The Country Club was the first area club, founded in 1889, although they begin to play golf until 1895. The Euclid Club was founded in 1900 and the golf course opened for play in 1901, as perhaps the first 18-hole course in the area. The architect was W.H. "Bertie" Way and the upper nine was on property owned by Mr. John D. Rockefeller. Mr. Rockefeller gave strict orders that there would be no play on Sundays, an order that would strongly influence the club's early demise. The above postcard shows the stately clubhouse. (Courtesy of the Marjorie Meltzer Collection.)

The Euclid Club had a spectacular but short life. It hosted many national, state, and local tournaments. The Western Open was held there in 1902 with Willie Anderson winning with a score of 299. Willie Smith and Bert Way tied for runner-up at 304. In the 1903 Western Amateur, also at the Euclid Club, Walter Egan defeated his cousin, H. Chandler Egan, one up for the championship. Between 1907 and 1912, the Euclid Club hosted four Cleveland City Championships for men and two city tournaments for women. It also hosted the 1910 Ohio State Tournament. The vintage postcard above shows some golfers on the course during that era. (Courtesy of the Marjorie Meltzer Collection.)

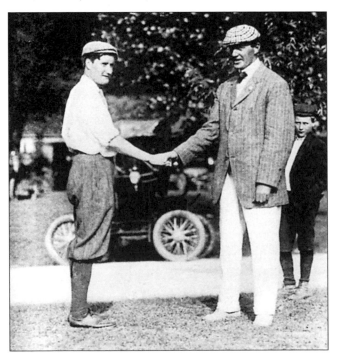

The most prestigious event at the Euclid Club was the 1907 U.S. Amateur. Jerome Travers won his first of four national amateurs, defeating Archibald Graham, 6 and 5. Travers also won a U.S. Open in 1915. He was only the second amateur to win the Open, following Francis Ouimet's victory in 1913. The photo at left shows Travers and Graham shaking hands after the match. (Courtesy of the Tillinghast Association.)

Jerome Travers is shown here with the Havemeyer Cup, the winner of the 1907 U.S. Amateur. He won it three more times, in 1908, 1912, and1913.

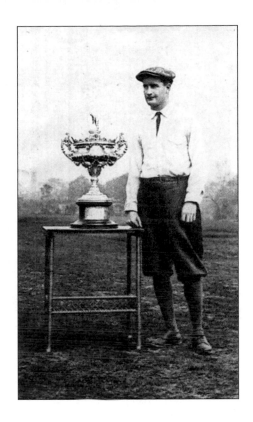

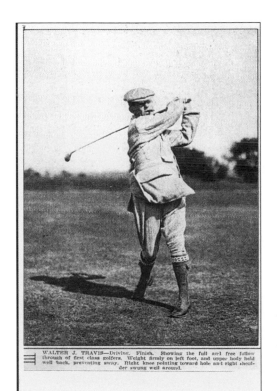

WALTER J. TRAVIS—Driving. Finish. Showing the full and free follow through of first class golfers. Weight firmly on left foot, and upper body held well back, preventing sway. Right knee pointing toward hole and right shoulder swung well around.

The medalist for the 1907 U.S. Amateur at the Euclid Club was Walter Travis. Mr. Travis shot 146 for the 36-hole qualifier. Travis had already won the tournament three times. The vintage photo at left shows Mr. Travis' classic swing for that era.

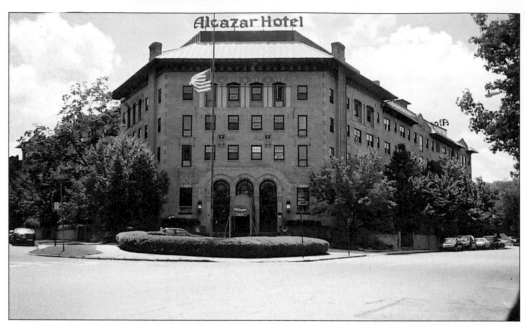

Alcazar Hotel

Many members left the Euclid Club in 1909 to start the Mayfield Country Club. It seems the Euclid Club tried to continue, hosting the Cleveland City Championship in 1911 and 1912. Another group of members left in 1912 to build a club in the new community of Shaker Heights. This apparently was too much of a loss, and the Euclid Club struggled until 1915 when it reopened the golf course for a while. There was seemingly additional pressure from the city to use that property for residential development. The Alcazar Hotel, shown above as it now stands, is located on part of the former Euclid Club golf course.

The Euclid Club

Cleveland
1909

John D. Rockefeller was at least partially responsible for the Euclid Club's presence, and its demise. The club had an illustrious but short life. The 1909 member's book shown left lists Mr. Rockefeller as an Honorary Member.

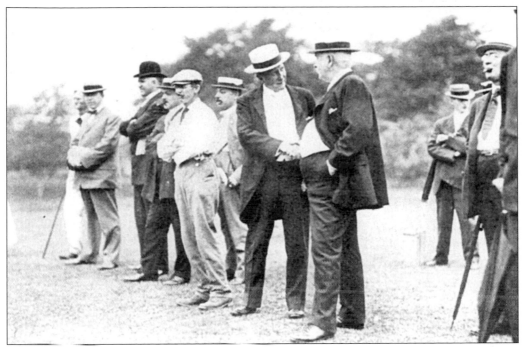

JOHN D. ROCKEFELLER AND GOLF. Rockefeller was an honorary member of the Euclid Club, which existed in the first part of the 20th Century, and the course's upper nine was on property he owned. The photo above shows John D. Rockefeller attending the 1907 U.S. Amateur Championship at the Euclid Club. (Courtesy of the Tillinghast Association.)

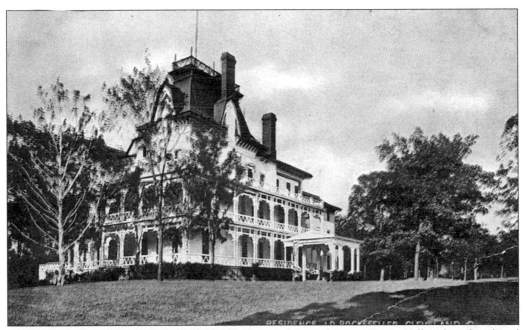

Mr. Rockefeller had a nine-hole private golf course at his residence in Forest Hills, where he played with his friends. Forest Hills was some distance from the Euclid Club and is now a public park. His residence no longer exists. The vintage postcard above shows the Rockefeller residence.

Although he was very competitive in business, Rockefeller apparently played golf mostly for the fresh air and exercise. He still tried to win while playing with his friends, but was gracious in defeat. Reportedly, Mr. Rockefeller started playing golf when he was past 60 years old, and kept playing till about age 95. The photo at left shows Mr. Rockefeller playing golf in Florida at about age 78. (Courtesy of *Golf Illustrated*.)

It was reported that in 1913, he walked the first five holes at Mayfield C.C. to watch a match between Harry Vardon and Edward Ray against local players Joe Bole and Eben Byers. Vardon and Ray easily won by nine shots with scores of 68 and 67. The British players were perhaps getting some revenge after losing to Francis Ouimet in a playoff for the U.S. Open at Brookline earlier in the summer. Harry Vardon is shown in the photo at right. (Courtesy of Northern Ohio Golf Association.)

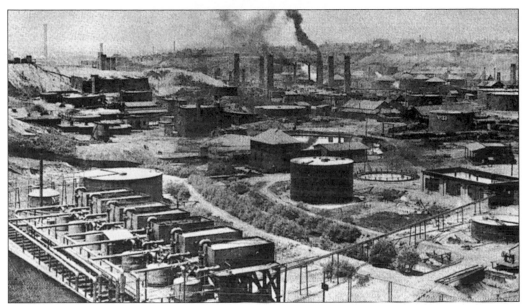

Mr. Rockefeller died in 1937 at the age of 98. He was mainly associated with the petroleum industry, starting in Cleveland. His first oil refinery was located in the Cleveland "Flats" and operated continuously for over 100 years. The Standard Oil Co. was started in 1870 in Cleveland. The photo above is Standard Oil's Cleveland Refinery as it looked in 1889. (Courtesy of the John Fraylick Collection.)

OBERLIN COUNTRY CLUB. One of the oldest golf clubs in Northeast Ohio is the Oberlin Country Club. The Oberlin Golf Association was formed on October 2, 1899. It's not clear when the first ball was struck or when the first nine holes were played or who did the course layout. Apparently Oberlin College personnel and local townspeople worked together to shape a nine-hole course. In 1922, the club members formed the Oberlin Golf Club Company. The course was reconstructed and lengthened by local members in the early 1920s. The first clubhouse was built in 1930. A second reconstruction took place in the 30s and was completed in 1939. Oberlin College has supported the club through the years and part of the course is on land leased from the college. The photo above shows part of the picturesque golf course. (Courtesy of Oberlin C.C.)

In 1952, the Oberlin Club decided to enlarge the course to 18 holes and they built a second clubhouse. A third clubhouse was built in 1965. Harold Paddock laid out the second nine and local personnel oversaw the construction. The new, second nine was opened in 1961. The club hosted a U.S. Open Qualifier in 1987. The photo at left is the 13th hole, a 130-yard par 3. (Courtesy of Oberlin C.C.)

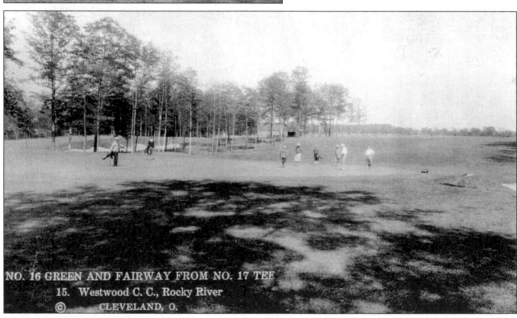

NO. 16 GREEN AND FAIRWAY FROM NO. 17 TEE
15. Westwood C. C., Rocky River
© CLEVELAND, O.

WESTEWOOD, DOVER BAY, AND KESWICK. The Westwood C.C. was incorporated in December 1913. Apparently the club had been playing at the Dover Bay Club course while they obtained a site for their own course. Bert Way designed the original course at their present site while he was the professional at Mayfield. The first nine opened on Decoration Day, 1915, and the second nine was to be ready for the following season. Play may have started in 1914 while the course was being built. C. H. Alison and H.S. Colt designed a new course in 1923. Shown above is a 1926 postcard of the 16th green and fairway from the No.17 tee. (Courtesy of the Marjorie Meltzer Collection.)

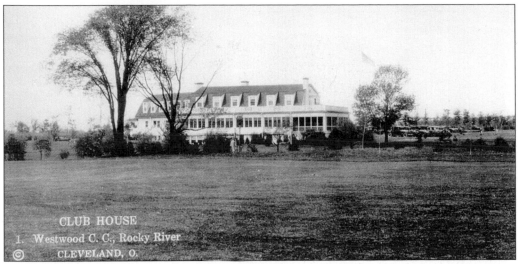

CLUB HOUSE
1. Westwood C. C., Rocky River
© CLEVELAND, O.

Many members left the Dover Bay Club in Bay Village and the Keswick Club in Rocky River to become members of Westwood. Dover Bay and Keswick no longer exist. Dover Bay may have had some holes of golf as early as 1890. It was built by members of the Dover Bay Colony. Bert Way apparently helped refine the course around 1904. The first clubhouse at Westwood was an existing farmhouse. A new clubhouse was built in 1918. The postcard shown above is the clubhouse as it appeared in 1926. (Courtesy of the Marjorie Meltzer Collection.)

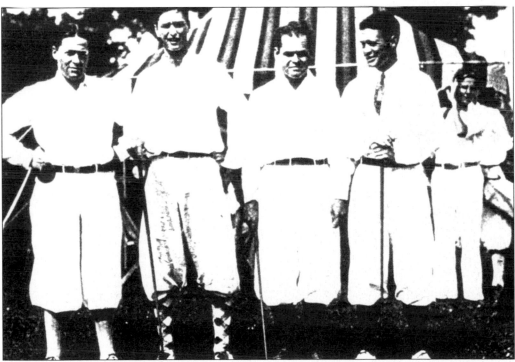

Bobby Jones played an exhibition match at Westwood in 1928. He was paired with a Westwood member, Doug Gorton. Their opponents were Watts Gunn, an acclaimed amateur from Atlanta, and former city champion, Jack Cummins. The foursome (from left to right): Bobby Jones, Jack Cummins, Doug Gorton and Watts Gunn.. (Courtesy of the Westwood C. C.)

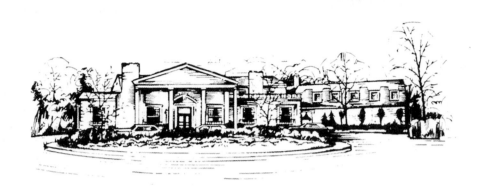

Westwood country club

ROCKY RIVER, OHIO

Westwood hosted the 1935 Women's Western Amateur Championship. Miss Mary K. Browne, the Cleveland Women's City Champion, tied for low medal score in the qualifier. Miss Marion Miley of Lexington, Kentucky, won the match play tournament defeating Mrs. Philip Atwood in the 36-hole final, 6 and 5. A recent Westwood scorecard is shown above. (Courtesy of Westwood C.C.)

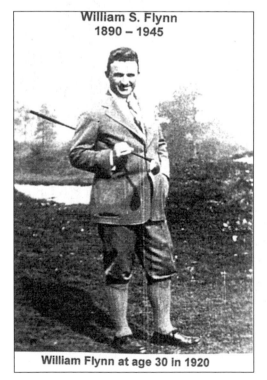

William S. Flynn
1890 – 1945

William Flynn at age 30 in 1920

ELYRIA COUNTRY CLUB. The Elyria Country Club was organized in 1905. Bert Way designed a nine-hole golf course of which seven holes were opened for play in 1906. The full nine holes were completed for play in 1907, and that original course remained until William S. Flynn designed a completely new 18-hole golf course in 1925. William Flynn also designed the Pepper Pike Club and The Country Club in Cleveland. He had other design projects of note, including Cherry Hills in Colorado, East Course at Merion with Hugh Wilson, Shinnecock Hills in New York, and the Cascades Course at the Homestead in Hot Springs, Virginia. Shown at left is a picture of Mr. Flynn. (Courtesy of Elyria C.C.)

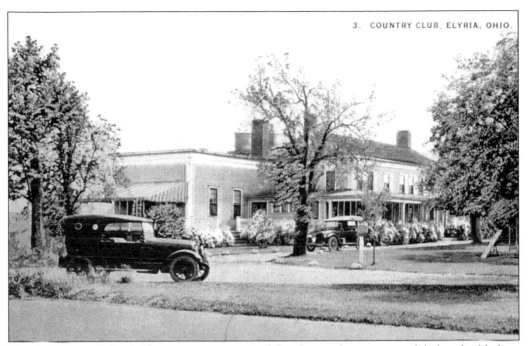

The first Elyria C.C. clubhouse was a renovated farmhouse that was remodeled and added-on over the years. The postcard above shows the clubhouse probably in the mid-to-late 1920s. (Courtesy of the Marjorie Meltzer Collection.)

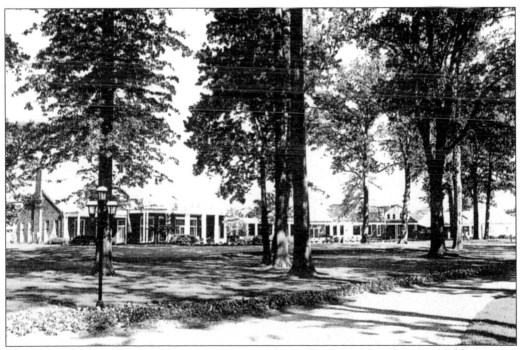

The original Elyria C.C. clubhouse was destroyed in a fire in 1947 and a new clubhouse was completed in 1950. There was a major expansion and renovation in 1997. The present clubhouse is shown above. (Courtesy of Elyria C.C.)

The golf course in 2004 plays to 6,731 yards and a slope rating of 130 from the back tees. Byron Nelson set the course record in 1940, with a score of 65. A modern scorecard is shown above. The scorecard face shows the 13th hole. (Courtesy Elyria C.C.)

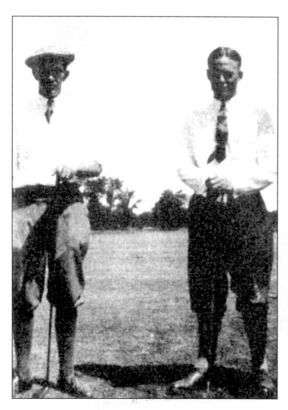

OAKWOOD CLUB AND THE 1921 WESTERN OPEN. The Oakwood Club hosted the 1921 Western Open, which was won by Walter Hagen with a score of 287. Jock Hutchison was runner-up at 292. The photo shows club professional, Dave Ogilivie Sr. with 19-year-old Bobby Jones during the tournament. Young Mr. Jones finished fourth at 294. (Courtesy Oakwood C.C.)

The Oakwood Club was organized in 1905 and the golf course was opened for play in 1906. Arthur Boggs, Oakwood's first professional, supervised the construction of a classic nine-hole course. Tom Bendelow, of Chicago, constructed the second nine, and this new 18-hole course was opened for play in 1915. In 1929, and again in 1972, the golf course underwent some reconstruction. The photo above show part of the golf course. (Courtesy Oakwood C.C.)

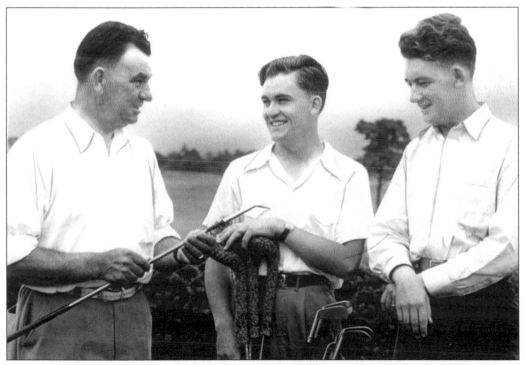

Dave Ogilvie Sr. was the club professional from 1916 until he passed away in 1950. His son, David Ogilvie Jr. succeeded him as the golf professional at Oakwood. The photo above shows Mr. Ogilvie Sr. with his two sons, both proficient golfers. (Courtesy of the Northern Ohio Golf Association.)

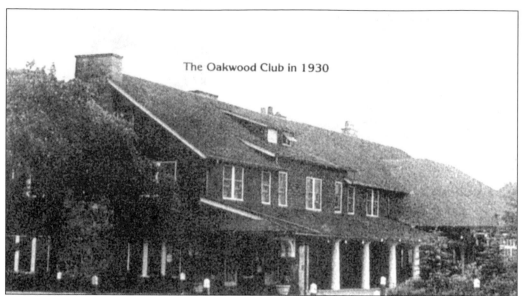

The Oakwood Club in 1930

The Oakwood clubhouse is shown here as it looked in 1930. (Courtesy Oakwood C.C.)

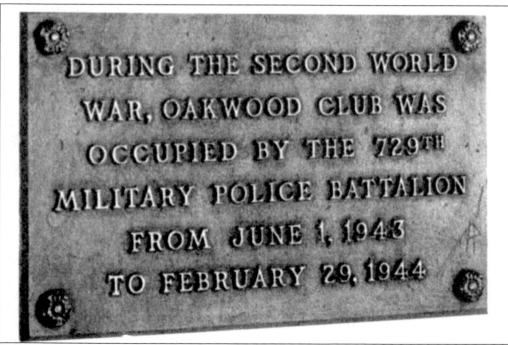

DURING THE SECOND WORLD WAR, OAKWOOD CLUB WAS OCCUPIED BY THE 729TH MILITARY POLICE BATTALION FROM JUNE 1, 1943 TO FEBRUARY 29, 1944

During the Second World War, Oakwood was occupied by the 729th Military Police Battalion from June 1, 1943 to February 29, 1944, as shown on the above plaque. (Courtesy Oakwood C.C.)

In an earlier version of the Cleveland Open, hosted by Oakwood in 1938, Ky Lafoon was the winner by one over Sam Snead. Snead was the victim of a strange incident, which probably cost him the tournament. His stroke to the final green overshot and was about to ricochet off the locker room back toward the green when someone opened the door and the ball finished inside the building. Sam Snead is shown at right. (Courtesy Northern Ohio Golf Association.)

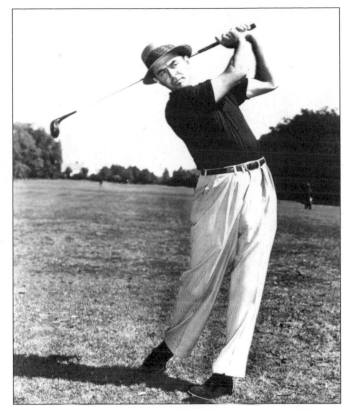

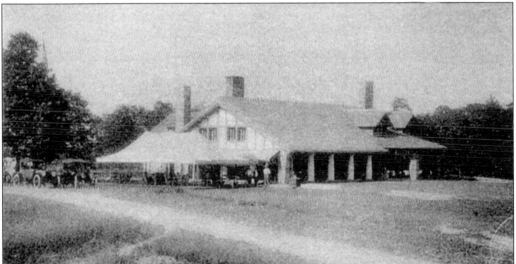

MAYFIELD COUNTRY CLUB. Mayfield C.C. was founded in 1909 by a group that was leaving the Euclid Club. The primary reason for the split was because nine holes of the Euclid Club was on Rockefeller property and he would not allow play on Sunday. Bert Way left the Euclid Club and designed the Mayfield course and became their club professional. The course opened for play July 15, 1911. Joe Bole, the city champion, had the best opening score, 77. The club was very well liked and the course gained national recognition. The postcard above is of the first clubhouse. (Courtesy of the Marjorie Meltzer Collection.)

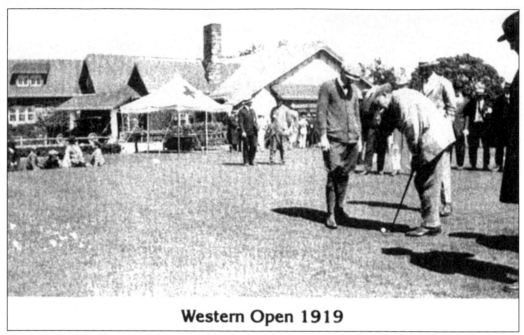

Western Open 1919

In 1919, Mayfield hosted the Western Open. This was the fourth of five times the Western Open was held at a Cleveland area course. The photo above is a scene from the 1919 Western Open. (Courtesy of Mayfield C.C.)

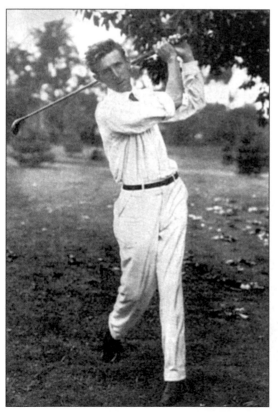

The winner at the 1919 Western Open at Mayfield was Jim Barnes with a score of 283. Leo Diegel finished second at 286. Walter Hagan did not do well on the last day and dropped from second place into a tie for seventh. Jim Barnes also won the Western Open in 1914 and 1917. He had four major championships: PGA 1916, 1919; U. S. Open 1921; and the British Open in 1925. He was known for long, straight drives. Jim Barnes is shown in the photo at left. (Courtesy of *Golfer Magazine*.)

Mayfield hosted two Western Amateurs, 1915 and 1923. Chick Evans was the winner both times. In fact, he won the Western Amateur eight times between 1909 and 1923. Evans also won the Western Open in 1910, plus two U.S. Amateurs and one U. S. Open. In 1916, he won both the U.S. Amateur and U.S. Open. In 1915, Evans defeated James Standish Jr., 7 and 6, in the final. In 1923, he defeated W.H. Gardner, 6 and 4, in the final. In the 1923 Western Amateur at Mayfield, Jess Sweetser was the Medalist at 143. The photo above is the 18th green at Mayfield. (Courtesy of the Northern Ohio Golf Association.)

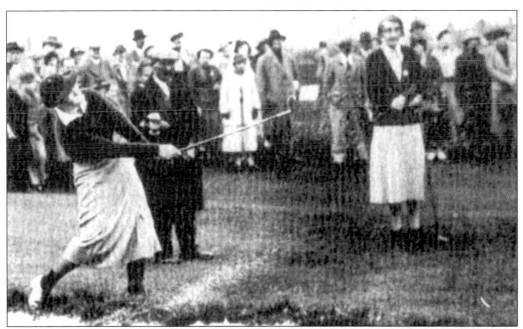

The U.S. Women's Amateur was played at Mayfield in 1920. Alexa Stirling, who grew up with Bobby Jones, was the winner. She defeated Mrs. J.V. Hurd, 5 and 4, in the final. The photo above is from the 1920 tournament at Mayfield. (Courtesy of Mayfield C.C.)

Mrs. Hurd, the runner-up for the 1920 U.S. Women's Amateur at Mayfield, was formerly Dorothy Campbell of Scotland, winner of 11 major championships, six of which were in North America. Three were in the U.S. and three in Canada. She won the U.S. Women's Amateur in 1909, 1910, and 1924. Pictured at left is Mrs. Hurd. (Courtesy of *Course & Clubhouse* magazine.)

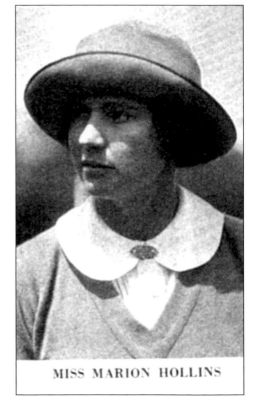

MISS MARION HOLLINS

Marion Hollins, another renowned lady golfer, was the medalist at the 1920 U.S. Women's Amateur at Mayfield. She had a score of 82. Miss Hollins would go on to win this tournament in 1921, defeating Miss Stirling in the final, 5 and 4. (Courtesy of *Golfer Illustrated*.)

Donald Ross was called in to modernize the Mayfield course in 1935. He recommended changes to all but three holes. The Mayfield course record was set in 1942 by Byron Nelson during the first round of the Ohio Open with a score of 29-34-63. Nelson birdied holes 3 through 9 for seven in a row. Nelson won the tournament for his third consecutive Ohio Open. His final score of 273 won by 5 strokes. Nelson was the pro at Inverness in Toledo at the time. Bob Lewis Jr., the Walker Cup player, tied Nelson's record of 63 forty years later in 1982. Shown at right is a Mayfield scorecard, c.1970. The yardage from the back tees is 6,613, and it's a par 71. (Courtesy Mayfield C.C.)

THE MAYFIELD COUNTRY CLUB
South Euclid, Ohio
Bob Hamrich, Professional
SCORE CARD

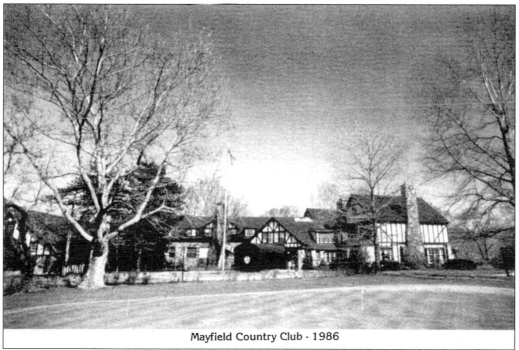

Mayfield Country Club - 1986

In 1948, there was a major clubhouse fire at Mayfield C.C. There had been previous smaller fires, so a total rebuild was done, along with some expansion. The photo above is the clubhouse as it looked in 1986. (Courtesy Mayfield C.C.)

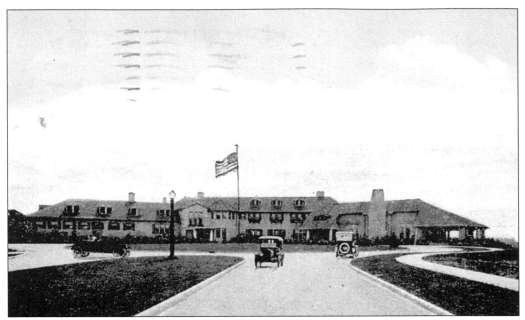

SHAKER HEIGHTS COUNTRY CLUB. The club was founded in 1913 by a group that left the old Euclid Club. The Donald Ross-designed golf course was opened for play in 1915. The original clubhouse also opened in 1915, with a gala dinner dance attended by 500 of Cleveland's notables. A distinguished local architect, Frank B. Mead, designed the clubhouse. He had previously designed the clubhouses of the Euclid Club and Mayfield County Club. Shown above is a vintage postcard of the Shaker Heights C.C. clubhouse. (Courtesy of the Marjorie Meltzer collection.)

Donald Ross used a fellow Scotsman, Grange (Sandy) Alves, to oversee the construction of the golf course. Mr. Ross was impressed with Mr. Alves' work at the French Lick Resort in Indiana. After the golf course construction was finished, Shaker Heights hired Sandy Alves as their greenkeeper and golf professional. Donald Ross, of Dornoch, Scotland, became one of the most noted and prolific course designers of all time. He was also a club maker and well versed in turf management. Most course designers are also very good players, and Ross, the club professional at Royal Dornoch and later at Pinehurst Resort, was no exception. Shown at left is a picture of Donald Ross' golf swing—it still looks good.

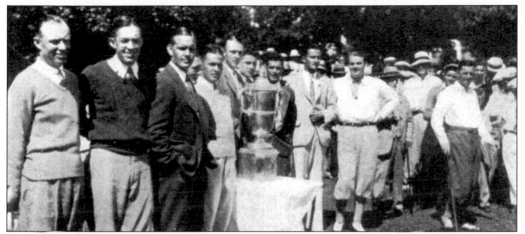

Some notable golfers from the past have played the Shaker golf course. In 1926, the reigning U.S. Open Champion, Walter Hagen, played in the inaugural "Shaker Day" and shot 66. Chick Evans played there in the late 1920s and thought holes 13, 14, and 15 were the best three-hole stretch he had ever played. Denny Shute was a member of Shaker's championship team in the 1920s. The photo above shows Chick Evans and the 1928 Walker Cup Team. Mr. Evans is the first one on the left. (Courtesy of *Golf Illustrated*.)

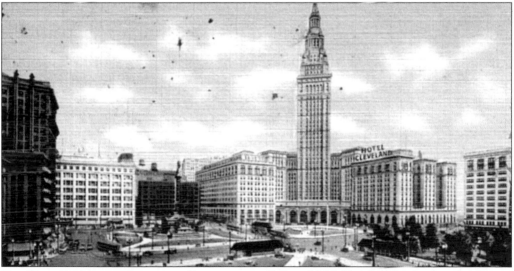

THE VAN SWERINGEN BROTHERS CONNECTION. O.P. and M.J. Van Sweringen were developing the Village of Shaker Heights around the same time a group of members from the Euclid Club were looking for a site on which to build a new country club for golf. The brothers accommodated the site selection and became founding members of the new Shaker Heights Country Club. The golf course was opened for play in 1915. Several years later they also provided land for The Country Club when developing the Pepper Pike community. The same O. P. and M. J. Van Sweringen were responsible for the great achievement of developing the downtown Terminal Tower complex. The complex included a rail station, office buildings, restaurants, shops, a hotel, post office, and department store, all connected so workers and travelers did not need to go outside. The terminal tower building is 52 stories high, and in 1930 was the tallest building in the world outside New York City. It still ranks as a unique center of commerce today. The Terminal Tower Complex is shown above in this vintage postcard.

GOLF ARCHITECTS IN NORTHEAST OHIO. Harold D. Paddock Sr., shown here, was born in San Diego, California, but his professional career in golf was based in Northeast Ohio. Although a golf professional, his fame is in golf architecture. At one time he owned and operated the Moreland Hills C.C. and the Aurora C.C. His design work was in the 1920s and, later, in the 1950s. He designed Spring Valley C.C. in 1926 and Columbia Hills C.C. in 1928. Mr. Paddock also designed Breathnach C.C. in Akron, and Pine Hill, Valleaire, and Avon Oaks C.C. Avon Oaks opened in 1961. (Courtesy of Northern Ohio Golf Association.)

W.H. "Bert" Way is shown here after retiring to Florida. Born in Scotland, he came to America as a young golf professional and was a very good player. In 1899, he was joint runner-up in the U.S. Open. In 1900, he designed the Euclid Club and became their golf professional. He designed the nine-hole Dover Bay course in 1904, according to Cornish and Whitten; however, Seagrave's book quotes Mr. Way as saying that the Dover Bay course already existed in 1900. In 1911, Mr. Way moved to the Mayfield Club and designed their course with Herbert Barker. Other notable courses designed by Bert Way include Aurora C.C. (1926) and Firestone-South (1929). Robert Trent Jones considerably strengthened the Firestone South course in 1960 but retained the basic layout of Bert Way's plan. Way was golf professional at Mayfield until 1952. He died in Florida in 1963 at the age of 90. He remained quite a good player into his 80s and was very well liked and appreciated by Mayfield and the PGA. (Courtesy of the Northern Ohio Golf Association.)

Two

A Generation of
New Gold Courses

Kirtland Country Club—Acacia Country Club—Beechmont Country Club—Madison Country Club—Willowick C.C. Becomes Manakiki—Sleepy Hollow—Hawthorne Valley Country Club—Spring Valley Country Club—Lake Forest Country Club—Columbia Hills Country Club—Berea C.C.-Riverside Golf Club—Grantwood Golf Club—Some Golf Courses That No Longer Exist

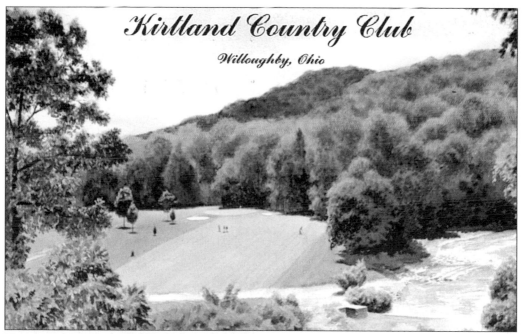

KIRTLAND COUNTRY CLUB. Opening in 1920, the course was built on the former estate of Mr. H.A. Everett. The architects were C.H. Alison and H.S. Colt. In 1930, Mrs. E.F. Lenihan, a Kirtland member, defeated Glenna Collett in a National Invitational tournament. Joyce Wethered, the famed British woman golfer, played an exhibition at Kirtland in 1935 and shot 74. In 1938, the Curtis Cup players, including Patty Berg, were in exhibition matches at Kirtland. Shown above is a picture of the course as it appears on the face of a scorecard. (Courtesy of Kirtland C.C.)

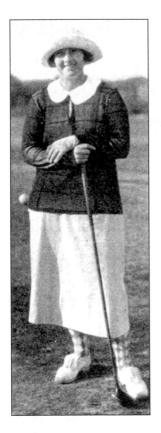

Miss Mary K. Browne, a former tennis champion, was a member at Kirtland and won several local and area tournaments in the 1920s and 1930s. She was the women's club champion in 1927 and 1930. Miss Browne qualified for the U.S. Women's Amateur several times, and was the runner-up in 1924, losing to Dorothy Campbell Hurd in the final. Miss Browne won the Women's Cleveland City Championship four times (1931, 1932, 1934 and 1935) and was the runner-up in 1933. The photo at left is Miss Mary K. Browne. (Courtesy of *Golf Illustrated*.)

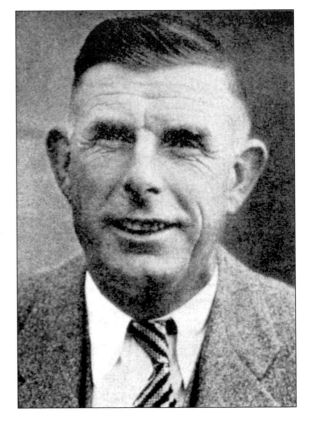

ACACIA COUNTRY CLUB. In 1921, a downtown Cleveland social group decided to take up golf and looked to acquire the necessary real estate for golf courses. The West-siders founded Lakewood Country Club and the East-siders founded Acacia Country Club. In 1922, Acacia opened a temporary nine-hole layout. Sandy Alves, the golf professional at Shaker Heights, came over to Acacia as their golf professional, and to help build a classic golf course. Donald Ross, who designed the Shaker golf course, was selected as the Acacia golf architect. He and Mr. Alves had worked together before. The photo at right is of Grange (Sandy) Alves. (Courtesy of the Cleveland Women's Golf Association.)

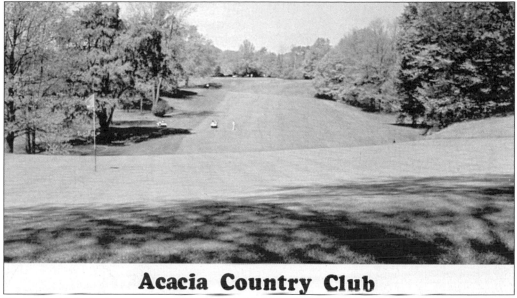

Acacia Country Club

The new 18-hole Acacia course was opened July 1, 1925. The first foursome included Chick Evans, who was a National Amateur and National Open Champion, Sandy Alves, club president Harry Tremaine, and club champion Nelson Davies. The Acacia golf course today is 6,744 yards from the back tees with a slope of 128. An Acacia scorecard is shown above. (Courtesy of Acacia C.C.)

BEECHMONT COUNTRY CLUB. The club was founded in 1923, and the first nine holes were opened in 1924. The architect was Mr. Stanley Thompson of Toronto, Canada. Additional property was purchased and the second nine holes were ready for play in 1924. Mr. Thompson also designed the Squaw Creek course in Vienna, Ohio, Chargrin Valley, and Sleepy Hollow. These are all outstanding courses in Northeastern Ohio, but perhaps Mr. Thompson's greatest achievement was to design Banff Springs and Jasper Park in the Canadian Rockies. Robert Trent Jones learned under the tutelage of Stanley Thompson and was his partner for a while. The photo above is the original 13th green. (Courtesy of Beechmont C.C.)

39

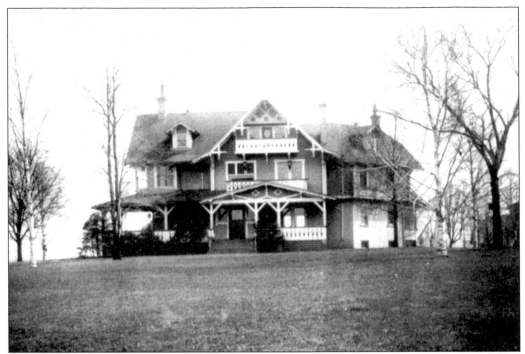

The original property for the Beechmont C.C. was the estate of F.W. Gehring of the Gehring Brewing Company. It had been acquired by Mr. Samuel Kornhauser around 1920 and was sold three years later to the Beechmont club. The property included a large house, which became the original clubhouse. The house/clubhouse is shown above. (Courtesy of Beechmont C.C.)

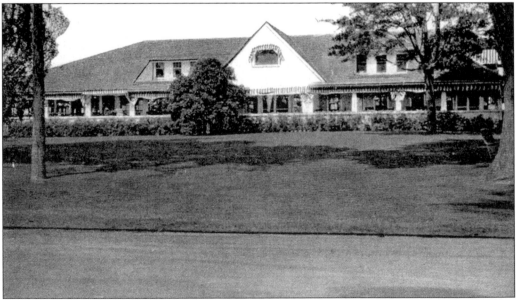

MADISON COUNTRY CLUB. The club opened in 1923 and was designed by Sandy Alves, who was the club golf professional at Acacia C.C. The course today plays to 6,487 yards with a slope of 129 from the back tees. Shown above is a vintage postcard of the Madison clubhouse. (Courtesy of the Marjorie Meltzer Collection.)

WILLOWICK C.C. BECOMES MANAKIKI. The Willowick Country Club incorporated in 1910 and opened for play on a nine-hole course the following year. In 1913, the club expanded to 18 holes and Jack Way, brother of Bert Way, became the club golf professional. The club hosted the 1915 Cleveland City Tournament, and H.E. Hollinger was the winner. In 1917, Jack Way began to rebuild the golf course with plans from Donald Ross. Apparently the Willowick members sought a better location, and in 1927 acquired about 160 acres of the Howard Hanna country estate. Perhaps developers wanted the original site. Other reports claim that the property (220 acres) was purchased by Mr. James Brown, a Cleveland businessman who owned Brown Fence & Wire Co. The sequence of events regarding the property acquisition is not clear but Mr. Brown did become the owner of the golf club. A picture of Mr. Brown's company brochure is shown at right. (Courtesy of the Marjorie Meltzer Collection.)

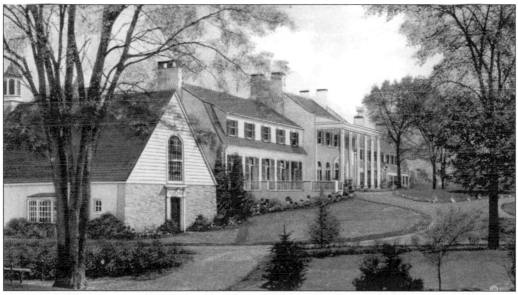

Willowick dropped their old name and the new club was called Manakiki. Mr. O.C. Wehe was the new, first president of Manakiki, and Lloyd Gullickson was the first golf professional. Donald Ross, the premier architect, was selected to design the Manakiki golf course and construction began in 1928. Mr. Ross said, "Every hole is different." The course opened for play June 28, 1929, at near 6,700 yards and a par 72. The Women's City Championship was held at Manakiki in 1934, with Mary K. Browne of Kirtland the winner. Joyce Wethered, the famed British lady golfer, played an exhibition at both Manakiki and Kirtland C.C. in 1935. The postcard shown here is a vintage picture of the clubhouse. (Courtesy of the Marjorie Meltzer Collection.)

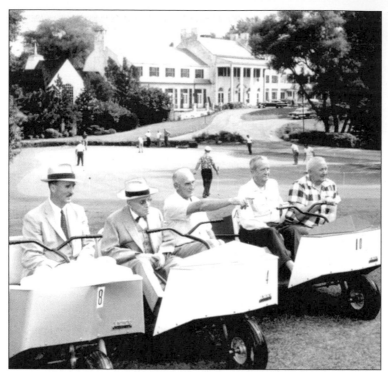

In 1944, James Brown sold the Manakiki Golf Course and facilities to the Cleveland Metropolitan Park Board for one dollar and on condition it remain a golf course. There is a plaque on the golf course in honor of Mr. Brown. The course kept operating as a private country club until January 1, 1961. At that time the Park Board opened it to public play. The photo at left shows park personnel looking over the course. (Courtesy of the Marjorie Meltzer Collection.)

MANAKIKI
PUBLIC GOLF COURSE
35501 Eddy Road
Willoughby Hills, Ohio 942 - 2500
Cleveland Metroparks

The Manakiki course has undergone some recent renovation to upgrade the playing conditions, but without changing the original Donald Ross design. Ross was apparently present during construction of the course, which cannot be said of many Ross designs. Many Ross trademarks are present in the Manakiki course—bunkers with grass walls and small rolling greens, open in front to allow bump and run approaches *a la* old Scottish courses. The current slope rating is 128 from the back tees. Tiger Woods conducted a golf clinic at Manakiki in 1994. Shown here is a recent scorecard. (Courtesy of the Manakiki Golf Club.)

SLEEPY HOLLOW. The Sleepy Hollow Golf Course was opened for play on the first nine holes in 1923, and all 18 in 1924. It started as a private club and became public in 1963. The Park Board annexed the property in 1924 and the club had to pay rent. Bill Barbour was the club pro from 1939 to 1974. He holds the course record, a 63. Sleepy Hollow's hilly terrain is very challenging and its high elevation lends to make it one of the most beautiful courses in the area. The vintage scorecard above is from the late 1960s. (Courtesy of Cleveland Metropolitan Park District.)

Charlie Sifford became the golf professional at Sleepy Hollow in 1975 and served there for 13 years. Charlie won two PGA Tour events and the 1975 Senior PGA Championship in a playoff with Fred Wampler. They tied at 280 and Charlie birdied the first playoff hole for the win. Sifford is a member of the Northern Ohio Sports Hall of Fame. The photo is from the program for the 2002 PGA Senior Championship. (Courtesy of Firestone C.C.)

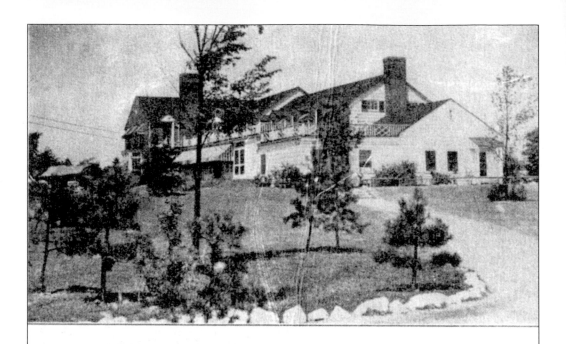

HAWTHORNE VALLEY
COUNTRY CLUB

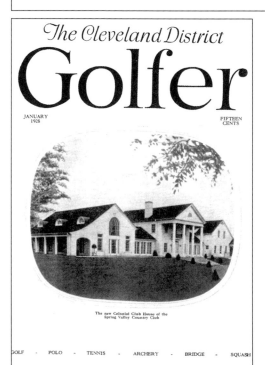

HAWTHORNE VALLEY COUNTRY CLUB. The club opened for play in 1926. The esteemed golf course architect, Donald Ross, designed the course. The course opened as a daily fee facility but became a private club in 1929. The first club professional at Hawthorne Valley apparently was Captain Charles Clarke, formerly of the British Horse Guards Regiment, who had seen duty in Egypt and South Africa. The course plays today at 6,462 yards with a slope of 133 from the back tees. Shown above is the face of a vintage scorecard with a picture of the clubhouse. (Courtesy of the Marjorie Meltzer Collection.)

SPRING VALLEY COUNTRY CLUB. The course was designed by Harold Paddock Sr. and opened for play May 26, 1926. A third nine was added in the next two years, but it was eventually abandoned. The *CLEVELAND DISTRICT GOLFER* magazine of January 1928 shows the clubhouse on its cover as seen at left. (Courtesy of the Northern Ohio Golf Association.)

Playing in the first group ever on the Spring Valley Course were: Larry Nabholtz, at that time the reigning Ohio Open Champion; Eddie Hasmann, Ohio State Amateur Champion; Bob Randall, Spring Valley Professional; and Jack Black, club pro at Elyria C.C. Hasmann and Nabholtz defeated Randall and Black in the nine-hole match with scores of 36-38. Randall and Black shot 38-41. More than 600 spectators followed the match. The photo at right shows Mr. Nabholtz and Mr. Randall. (Courtesy of *Golf Illustrated*.)

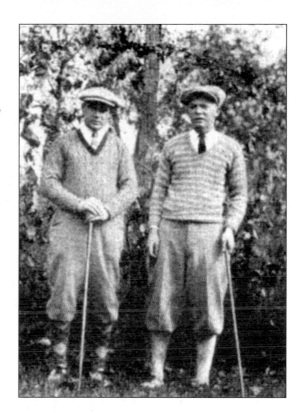

SCORE CARD

SPRING VALLEY COUNTRY CLUB

SEMI-PRIVATE

TELEPHONE 3177

GULF ROAD **ELYRIA, OHIO**

Starting during the Great Depression of the 1930s and through the war years in the 1940s, Spring Valley lost members and became a semi-private facility for several years. This vintage scorecard is from that era. (Courtesy of the Marjorie Meltzer Collection.)

45

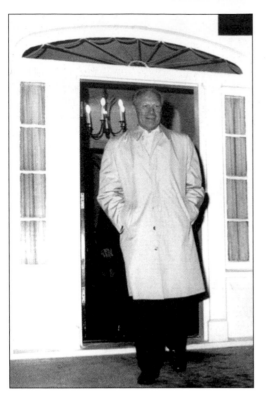

During the 1980s and early 1990s, Lorain County Community College (LCCC) sponsored a Prominent American Lecture Series. Speakers included U.S. Presidents, sports figures, authors, astronauts, actors, and media personalities. The lectures were held on campus but many were hosted at Spring Valley C.C. for dinner. President Gerald Ford is shown here leaving the clubhouse in 1987. Mr. Ford was the 38th U.S. President, serving 1974 through 1977. (Courtesy of the Richard Mellott Collection.)

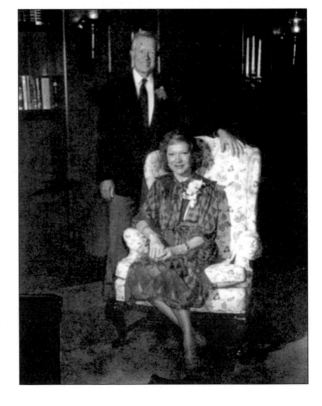

Another U.S. President, Jimmy Carter, with wife Rosalynn, came in 1985 for the LCCC Prominent American Lecture Series and dined at Spring Valley C.C. Mr. Carter was the 39th president, serving 1977 through 1981. The photo at right is in the Fireside Room. (Courtesy of the Richard Mellott Collection.)

In 1960, Arnold Palmer and George Bayer played an exhibition match at Spring Valley against Charlie Smith, the club pro at that time, and local member Bob McIlvain. Palmer shot 65 and Bayer 67. The course was modified during the final years of the 20th Century, to add length and improve playability. Architect Brian Huntley developed the modification plan. The current yardage is 6,555 from the back tees with a slope of 128. The current scorecard shows the new No. 13 green, a downhill par 3. (Courtesy of Spring Valley C.C.)

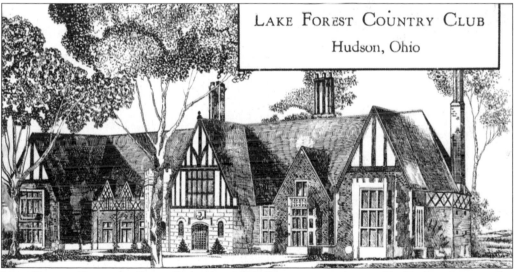

LAKE FOREST COUNTRY CLUB. Opened in 1930, the course was designed by Herbert Strong, who also designed Canterbury G.C. The course was located in Hudson, in an area being developed by S.H. Kleinman. Walter Hagen, Tommy Armour, Horton Smith, and Denny Shute flew in via the Goodyear Blimp to test the new course. Hagen and Shute defeated Armour and Smith with 5 over par 77. The course was set up to play at 6,890 yards, Ohio's longest at the time. Shute became the club's first golf professional. Lake Forest C.C. had to close during the Great Depression of the 1930s and remained closed for nearly 20 years. The club was reactivated January 24, 1950, when William Alves was appointed head professional and groundkeeper. The course required significant restoration and has undergone several modifications since. The nines have been reversed from the original plan. Shown above is the face of a vintage scorecard from the Marjorie Meltzer Collection. (Courtesy of Lake Forest C.C.)

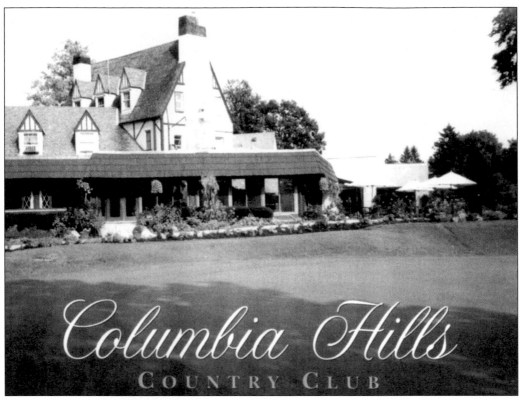

Columbia Hills
COUNTRY CLUB

COLUMBIA HILLS COUNTRY CLUB. The club is celebrating the 75th Anniversary of its golf course in 2004. The course was designed by Harold Paddock and constructed in 1927–28. It was a daily fee course until 1963, when the membership purchased the course complete with its Tudor clubhouse. The clubhouse survived a fire in 1974 and has undergone many additions and renovations, including a major upgrading in 1998. The picture above shows the clubhouse after that last makeover. (Courtesy of Columbia Hills C.C.)

The golf course is somewhat short by today's standards at 6,432 yards from the back tees, but has a healthy slope of 134. The golf course has also seen some changes and improvements over the years. Jason Dufner, a current member of the PGA Tour, grew up playing golf at Columbia Hills. The picture at left shows some of the golf course. (Courtesy Columbia Hills C.C.)

THE BEREA COUNTRY CLUB–RIVERSIDE GOLF CLUB. Berea C.C. started as a private club in the late 1920s and continued through most of the 1930s. It became a daily fee golf facility, apparently about 1938. Seagrave's book reports that a second nine holes were built in 1929 and all 18 holes were in play in 1930. By 1937, it was no longer listed as Berea C.C. in the roster of the Western Division clubs of the Cleveland District Golf Association. When it changed names to the Riverside Golf club is unknown. (The course architect was apparently J.W. Bagley, who is not listed in Cornish & Whitten's book of architects.) What is known is that Marion Reid served as the club professional for at least 50 years, according to a plaque presented in 1988 by the Riverside Women's Golf Association for 50 years of service. Reportedly, Mr. Reid was stationed in Panama in 1944 with the U.S. Army and won the 1944 Panama Open. The Riverside golf course is relatively short and plays to a par of 69, but has three long difficult holes. A scorecard from about 1960 is shown above. (Courtesy of Riverside Golf Club.)

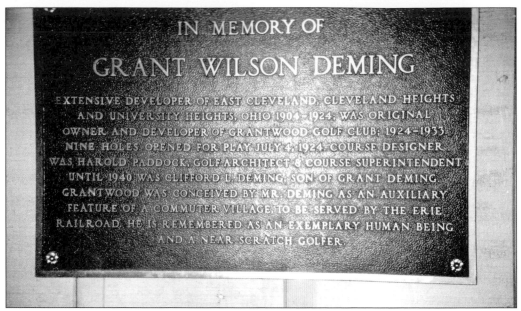

GRANTWOOD GOLF CLUB. A developer named Grant Wilson Deming purchased land in what is now the city of Solon, Ohio. He envisioned a community of fine homes and a golf course. The first nine holes were opened in July 1924, and the course was named Grantwood. The photo above shows a plaque outside the clubhouse in memory of Mr. Deming. (Courtesy of Grantwood G.C.)

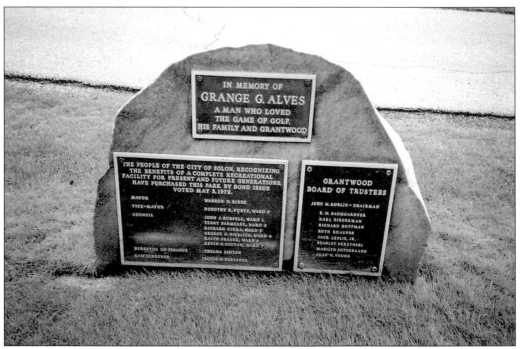

Grange Alves, former professional at Shaker Heights and Acacia, purchased the Grantwood Golf Course in 1953. He operated the course for nearly 20 years. In 1972, the city of Solon purchased the golf course. The photo above is a plaque at Grantwood, near the clubhouse, in memory of Mr. Alves. (Courtesy of Grantwood G.C.)

The architect for the Grantwood golf course was Harold Paddock Sr. The course today is a 6,429-yard par 71 from the back tees. The scorecard above is from the early 1960s. (Courtesy of Grantwood G.C.)

SOME GOLF COURSES THAT NO LONGER EXIST. This cover of the score card for the 18-hole University Heights Golf Course may bring back some memories for the senior golfers in the area. This course is no longer in existence, but played to 6,040 yards and was open to the public. (Courtesy of the Marjorie Meltzer Collection.)

JULY 22, 1943

UNIVERSITY HEIGHTS
GOLF COURSE

Cedar Road at
Warrensville Center Road

Tel. Fairmount 9704

TED HUGE, PROFESSIONAL

Copyright, 1942. Pictorial Score Card Co., Inc. N. Y. C. Series B—No. 4

Another 18-hole public course that has gone out of existence was the Mayfield Heights Golf Course. It was a par 72 layout playing at 6,455 yards. At left is an old scorecard from the course. (Courtesy of the Marjorie Meltzer Collection.)

Lyndhurst Golf Course was just a 9-hole course, par 35 and 2,515 yards. It was still in existence in the late 1940s. (Courtesy of the Marjorie Meltzer Collection.)

THREE

Early Professional Tournaments, Sites, and Players

Canterbury Golf Club–The Beginning—Canterbury Hosts Two Western Opens—1953 and 1954 Carling Open at Manakiki—Firestone Country Club—Denny Shute—Herman Keiser—The Sharon Golf Club Tom Weiskopf-Champion Golfer from Cleveland

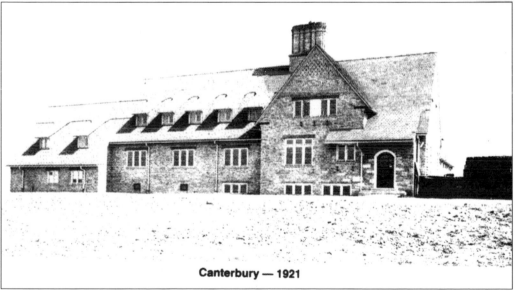

Canterbury — 1921

CANTERBURY GOLF CLUB—THE BEGINNING. Some members of the downtown University Club of Cleveland decided in 1920 to start a new golf club. The official date for the founding of the club was February 2, 1921. The name Canterbury was chosen as a tie in to Moses Cleaveland, who started the settlement that became the city of Cleveland. Canterbury, England, was Moses Cleaveland's hometown. A hilltop site was selected that now borders between the suburbs of Shaker Heights and Beechwood. Shown above is the initial unit of the clubhouse that was built in 1921. (Courtesy Canterbury G.C.)

MEN'S COURSE							WOMEN'S COURSE		
Long Course	Reg. Course	Par	Hdcp.	Holes			Hdcp.	Par	Yardage
430	422	4	3	1			7	5	405
372	346	4	13	2			13	4	331
180	143	3	17	3			17	3	118
439	418	4	5	4			5	5	401
405	382	4	7	5			9	4	375
500	470	5	11	6			3	5	453
201	168	3	15	7			15	3	142
410	363	4	9	8			11	4	356
535	529	5	1	9			1	5	515
3472	3241	36	OUT				38	3096	
360	352	4	14	10			12	4	322
165	137	3	18	11			18	3	122
372	348	4	12	12			14	4	303
490	472	5	8	13			4	5	448
385	369	4	4	14			8	4	351
358	346	4	10	15			10	4	324
605	590	5	2	16			2	6	578
232	215	3	16	17			16	4	188
438	391	4	6	18			6	4	386
3405	3220	36	IN				38	3022	
6877	6461	72	TOTAL				76	6118	

Player Attest Date

Herbert Strong was selected to design the Canterbury Golf Course, which was opened for play in 1922. Mr. Strong came to America several years earlier as a club professional and later went into golf architecture. In England, he worked at St. George Golf Club as a golf professional and clubmaker. Canterbury was perhaps his greatest achievement. He also designed Lake Forest in Northeast Ohio. Shown at left is a Canterbury scorecard from the 1970s. Please note the three strong finishing holes. (Courtesy of Canterbury G.C.)

Le Club Laval-sur-le-Lac

RÈGLE DU JEU

Une équipe retardataire doit laisser passer celle qui la suit, lorsque le parcours suivant est libre.

BORNES DU TERRAIN

Les clôtures qui longent les parcours 2, 3, 4, 5, 6, 8 9, 12 et 14.

Veuillez observer les règles et l'étiquette du jeu.

Other courses designed by Herbert Strong include Clearwater C.C. and Rio Mar in Florida, Saucon Valley in Pennsylvania, and the Army-Navy C.C. in Virginia. He was also active in Canada. One of his Canadian designs was Le Club Laval-sur-le-Lac in Quebec. Shown at right is a scorecard for the Quebec course from the Quebec Spring Open, June 1, 1951.

The first golf professional at Canterbury was Jack Way, brother of Bert Way, who was the club professional at Mayfield. Jack Way and others made some design improvements to the Canterbury Golf course prior to hosting the 1932 Western Open. Canterbury has had several fine head professionals over the years. Perhaps the most noteworthy was Henry Picard, who was there from 1946 to 1964. Mr. Picard won the Masters in 1938 by 2 strokes with a score of 285. He also won the PGA Championship in 1939, defeating Byron Nelson in the final with birdies at the 36th and 37th holes. He was a member of Ryder Cup teams in 1935, 1937, and 1939, and finished sixth in both the 1935 U.S. and British Opens. In 1961, Picard, pictured at right, was elected to the PGA Hall of Fame. (Courtesy of Canterbury G.C.)

CANTERBURY HOSTS TWO WESTERN OPENS.
Canterbury hosted the 1932 and 1937 Western Open tournaments. In 1932, the course was just 10 years old. The entrance to the club in 1932 ,as shown in this photo, looks a little different then it does today. The Western Open is still a significant tournament and was even more so in 1932. (Courtesy of Canterbury G.C.)

Entrance to Canterbury — 1932

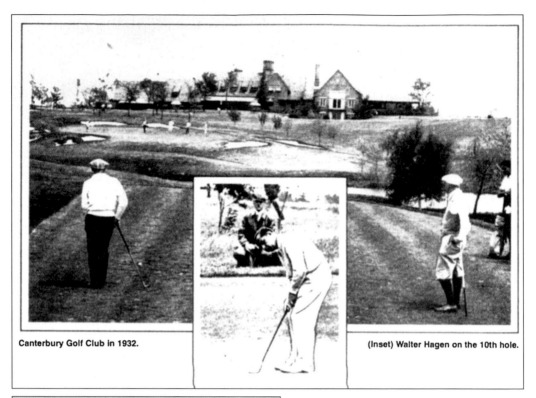

Canterbury Golf Club in 1932.

(Inset) Walter Hagen on the 10th hole.

Walter Hagen won the 1932 Western Open with a score of 287. This 1932 photo appears to be the No. 3 hole, a par 3, with the clubhouse in the background. The inset picture is Mr. Hagen on the 10th hole. This was the last significant victory for the flamboyant Mr. Hagen. He won two U.S. Opens, five PGA Championships, and four British Opens. This was his fifth Western Open title. He was a member of six Ryder Cup teams, and he captained the 1937 team. (Courtesy of Canterbury G.C.)

Olin Dutra was runner-up to Hagen in the 1932 Western, losing by only one stroke. Dutra went on to win the 1932 PGA Championship and 1934 U.S. Open. He also finished third in the 1935 Masters and was a Ryder Cup team member in 1933 and 1935. (Courtesy of the Northern Ohio Golf Association.)

The 1937 Western Open at Canterbury was won by Ralph Guldahl in a playoff with Horton Smith. They tied at 288, and Guldahl won the 18-hole playoff by four shots with a score of 72. Both players were at the top of their game during this era. Horton Smith had won the first Masters tournament in 1934 and again in 1936. Smith double bogied the 18th hole on the final day, when he hit his tee shot out of bounds. This allowed Guldahl to get the tie during regulation play. The 18th hole is depicted at right. (Courtesy of Canterbury G.C.)

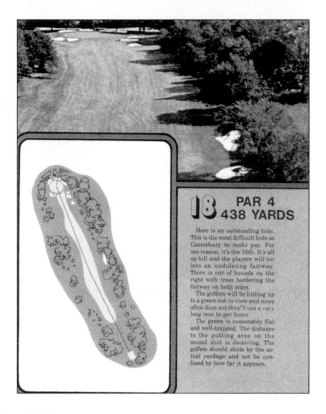

18 PAR 4
438 YARDS

Here is an outstanding hole. This is the most difficult hole at Canterbury to make par. For one reason, it's the 18th. It's all up hill and the players will hit into an undulating fairway. There is out of bounds on the right with trees bordering the fairway on both sides.

The golfers will be hitting up to a green not in view and more often than not they'll use a very long iron to get home.

The green is reasonably flat and well-trapped. The distance to the putting area on the second shot is deceiving. The golfers should abide by the actual yardage and not be confused by how far it appears.

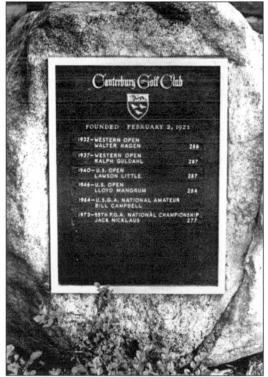

Guldahl was to win the U.S. Open in both 1937 and in 1938. His Western Open win at Canterbury in 1937 was also his second in a row, and he made it three straight the following year. He also won the Masters in 1939. The Canterbury plaque at left shows Ralpah Guldahl's 1937 Western Open triumph. (Courtesy of Canterbury G.C.)

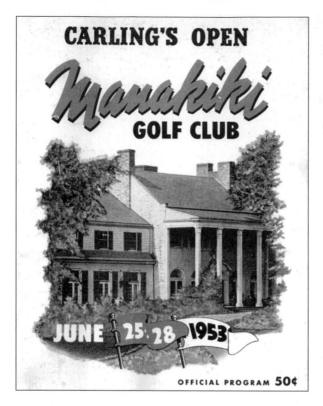

CARLING'S OPEN
Manakiki
GOLF CLUB

JUNE 25-28 1953

OFFICIAL PROGRAM 50¢

1953 AND 1954 CARLING OPEN AT MANAKIKI. The professional golf tour came to Cleveland for the Carling Open in 1953 and 1954. Both events were held at the Manakiki Golf Club. Shown here is the program cover for the June 25–28, 1953 tournament. (Courtesy of the Marjorie Meltzer Collection.)

Many of the top professionals of that era participated in the 1953 and 1954 Carling Open at Manakiki. The 1953 winner was Cary Middlecoff and the 1954 winner was Julius Boros. Other notable participants were Jimmy Demaret, Jim Turnesa, Porky Oliver, and Sam Snead. Snead tied for 16th and Arnold Palmer, playing as an amateur, tied for 47th in the 1953 event. Dr. Middlecoff is shown here in a vintage photo. (Courtesy of the Northern Ohio Golf Association.)

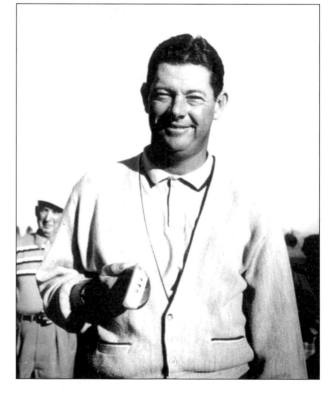

FIRESTONE COUNTRY CLUB. This is perhaps the most well known golf facility in America due to its television exposure over the years, hosting many professional golf tournaments. Its trademark was the golf ball shaped water tower with the name Firestone on it, shown here on the cover of the 1966 PGA program. Firestone C.C. now has three championship courses. The South Course was designed in 1929 by Bert Way and the members were nearly all employees of the Firestone Co. The first tournament for professionals was the 1954 Rubber City Open. The tournament was held through 1959. There was a 1953 Rubber City Invitational at Breathnach C.C. in Cuyahoga Falls, won by Art Well Jr. In 1960 Firestone hosted the first of three PGA Championships. Below is a list of the winners of the Rubber City Open.(Courtesy of Firestone C.C.)

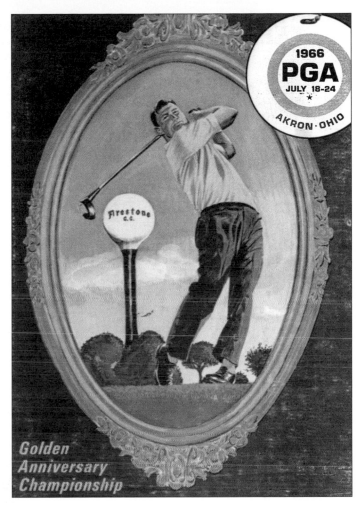

FIRESTONE C.C. RUBBER CITY OPEN

Year	Winner	Score
1954	Tommy Bolt	265
1955	Henry Ransom	272
1956	Ed Furgol	271
1957	Arnold Palmer	272
1958	Art Wall Jr.	269
1959	Tom Neiporte	267
1960	(Not held due to hosting the PGA Championship)	

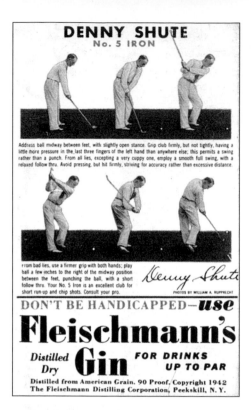

DENNY SHUTE
No. 5 IRON

Address ball midway between feet, with slightly open stance. Grip club firmly, but not tightly, having a little more pressure in the last three fingers of the left hand than anywhere else; this permits a swing rather than a punch. From all lies, excepting a very cuppy one, employ a smooth full swing, with a relaxed follow thru. Avoid pressing, but hit firmly, striving for accuracy rather than excessive distance.

From bad lies, use a firmer grip with both hands; play ball a few inches to the right of the midway position between the feet, punching the ball, with a short follow thru. Your No. 5 Iron is an excellent club for short run-up and chip shots. Consult your pro.

Denny Shute

PHOTOS BY WILLIAM A. RUPPRECHT

DENNY SHUTE. Densmore "Denny" Shute was born in Cleveland in 1904. He died in 1973 after an illustrious career in golf. Denny Shute served many years as the club professional for the Portage Club in Akron. This instructional card appeared on the back of a scorecard. (Courtesy of the Marjorie Meltzer Collection.)

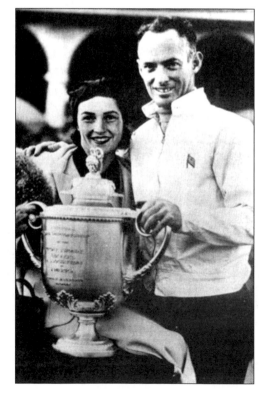

As a professional, Denny Shute won two PGA Championships (1936 and 1937). He won the British Open in 1933 with four rounds having identical scores (73-73-73-73) for a 292 total. Shute was a member of Ryder Cup teams in 1931, 1933 and 1937, and he tied with Byron Nelson and Craig Wood for the 1939 U.S. Open, losing in the first 18-hole playoff round. Nelson was the eventual winner over Wood in a second 18-hole playoff. Shute was also runner-up to Craig Wood in the 1941 U.S. Open. The photo shows Mr. Shute with the PGA trophy. (Courtesy of Firestone C.C.)

Denny Shute was noted to have a smooth swing and to be a great shotmaker. He won the Ohio Amateur in 1927 and four Ohio Opens (1929–31 and 1950). He learned to handle pressure early. Apparently he was a member of Shaker Heights C.C. as a young amateur, as a Shaker's history book reports that he played on their championship team. The photo at right is from the 1965 Cleveland Open program.

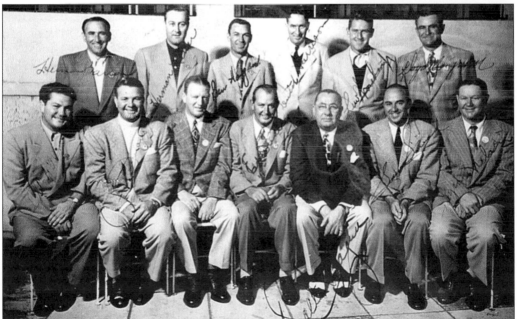

HERMAN KEISER. Keiser won the 1946 Masters Tournament, despite three-putting the last hole—Ben Hogan also three putted No.18 to finish second. Mr. Keiser won four other professional tour events and was a member of the 1947 Ryder Cup team. The above photo of the team hangs on the wall of the Loyal Oak golf clubhouse in Norton, Ohio. Mr. Keiser is second from the left in the back row. (Courtesy of Art Gruber, present owner of Loyal Oak Golf Course.)

Herman Keiser moved to Ohio in 1940. He was an assistant golf professional at the Portage Country Club and then the head professional at Firestone Country Club. He won the Ohio Open Championship in 1949 and 1951. The picture at left of Mr. Keiser also hangs in the Loyal Oak Clubhouse. (Courtesy of Art Gruber.)

Mr. Keiser and a partner purchased the Loyal Oak Golf Course about 1952. The course is located in Norton, Ohio, just west of Akron. He sold his interest in Loyal Oak about 1961 and built a driving range in nearby Copley, Ohio. The driving range was once the site of the Copley Airport. Mr. Keiser went back to Augusta regularly to play in the Masters and attend the championship dinner. He died December 24, 2003. He and Denny Shute were honorary members of the Sharon Golf Club. Shown above is the Loyal Oak sign and clubhouse. (Courtesy of Art Gruber.)

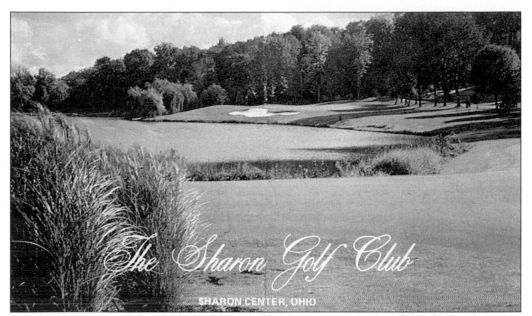

The Sharon Golf Club

SHARON CENTER, OHIO

THE SHARON GOLF CLUB. Opened in 1966, the course was designed by George W. Cobb, who designed many golf courses, mostly in the southeastern states. Sharon was his only project in Ohio. Mr. Cobb became a design consultant to Augusta National during the 1950s and 1960s, and became a good friend of Bobby Jones. Cobb designed the par 3 course at Augusta National with Mr. Jones. The Sharon course is 7,203 yards par 72 from the championship tees. Pictured above is a golf course scene on the front of their scorecard. (Courtesy of The Sharon Golf Club.)

The Sharon Golf club hosted the 1972 U.S. Men's Senior Amateur. The winner was a highly regarded amateur, Lewis W. Oehmig. Mr. Oehmig won several state championships in his home state of Tennessee. He also was the non-playing captain of the 1977 U.S. Walker Cup team that was victorious at Shinnecock Hills. Pictured here is The Sharon Golf Club crest. (Courtesy of The Sharon Golf Club.)

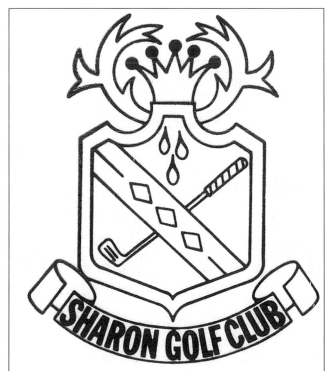

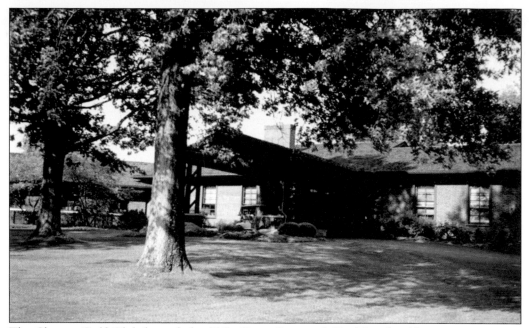

The Sharon Golf Club hosted the U.S. Open Sectional Qualifier for 18 consecutive years starting in 1975. It also hosted the Ohio Amateur Championship in 1980 and again in 1990. The Sharon clubhouse is shown above. (Courtesy of The Sharon Golf Club.)

TOM WEISKOPF—CHAMPION GOLFER FROM CLEVELAND. Weiskopf was born in 1942 in Massillon, Ohio, and grew up in the Cleveland area. He became one of the most outstanding golfers of all time. He started playing golf at age 15 and soon became good enough to win three consecutive Ohio Public Links Championships and the 1963 Western Amateur. He attended Ohio State University and was a teammate of Jack Nicklaus. (Courtesy of the Richard Mellott Collection.)

Tom joined the PGA Tour in 1965 and won 15 career tournaments on the regular tour plus the 1973 British Open at Troon, Scotland, and the 1973 World Series of Golf at Firestone. He was runner-up in four Masters Tournaments. In 1995, he won the U.S. Senior Open, shooting 275 at Congressional C.C. (Courtesy of the Richard Mellott Collection.)

In the last several years, Mr. Weiskopf has become a noted golf course architect. He has teamed with Jay Morrish to design outstanding courses such as Double Eagle in Galena, Ohio; Forest Highlands in Flagstaff, Arizona; and Loch Lomond, Scotland. Tom now lives in Arizona, but returned to Ohio in June 1996 to be the host professional at the Lorain County Community College Jack Nicklaus Scholarship Benefit Golf Outing. (Courtesy of the Richard Mellott Collection.)

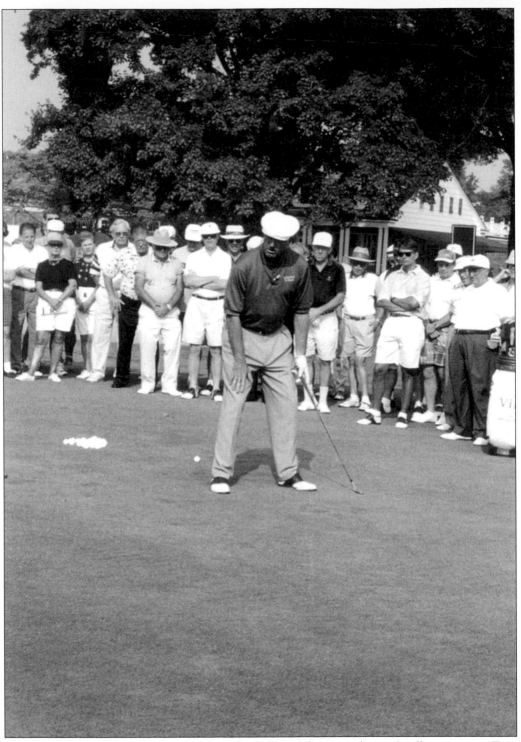

The annual golf benefit is named after Jack Nicklaus who started it and still supports it. Tom Weiskopf gave a clinic, and even his mother came to watch, which pleased Tom very much. (Courtesy of Richard Mellott.)

Four

The Cleveland Open and More

Beechmont Hosts the Inaugural Cleveland Open—Highland Park and the Cleveland Open—
Lakewood, Tillinghast, and the Cleveland Open—Aurora C.C. and the Cleveland Open—
Tanglewood C.C. and the Last Cleveland Open—Quail Hollow Resort and Country Club—
Quail Hollow and the Greater Cleveland Open

BEECHMONT HOSTS THE INAUGURAL CLEVELAND OPEN. Shown here is the cover of the 1963 Cleveland Open Program in its first year and held at the Beechmont Country Club. Beechmont was 40 years old that year and played to 6,618 yards at a par of 71. The total purse that year, at $110,000, was the largest ever up to then, and the winner was Arnold Palmer whose career earnings had already become the most of any golf professional player at that date. (Courtesy of Beechmont C.C.)

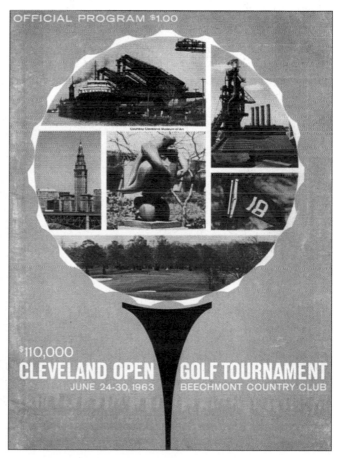

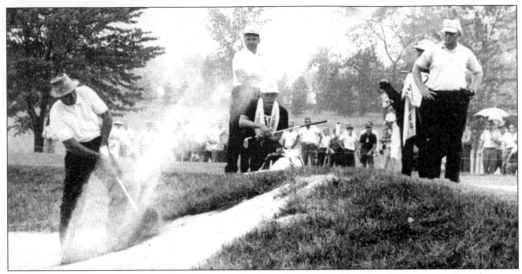

Every major tour professional came to play in the 1963 Cleveland Open at Beechmont. Included in the field were Nicklaus, Palmer, Trevino, Lema, Player, Casper, and Sam Snead. The photo above shows Mr. Snead blasting out of a bunker while Jack Nicklaus looks on from the green. (Courtesy of Beechmont C.C.)

Palmer scored 273 to tie Tony Lema and then won the playoff. Lema turned the tables on Palmer the following year, winning this tournament in a playoff with Palmer. It was played at Highland Park in 1964. Shown above are tickets for those first two tournaments. (Courtesy of the Marjorie Meltzer Collection.)

Beechmont hosted the Cleveland Open once again in its next-to-last year, 1971. The winner that year was Bobby Mitchell with a score of 262. It was Mitchell's first win after six years on the tour, and he won by seven strokes over Charles Coody. A vintage Beechmont scorecard is shown at right from the Marjorie Meltzer Collection. (Courtesy of Beechmont C.C.)

HIGHLAND PARK AND THE CLEVELAND OPEN. Highland Park hosted the 1964 and 1965 Cleveland Opens. Tony Lema and Arnold Palmer battled to a tie in both '63 and '64. They each won a playoff, first Palmer and then Lema. Tony treated the press to champagne, as was his custom. The photo at left, from the 1965 program, shows the genial Mr. Lema toasting the win in 1964.

Dan Sikes Jr. won the 1965 Cleveland open at Highland Park with a score of 272. The picture at left is the cover of the 1965 tournament program.

LAKEWOOD, TILLINGHAST, AND THE CLEVELAND OPEN. Lakewood hosted the Cleveland Open Tournament twice, in 1966 and 1968. The 1966 winner was R.H. "Dick" Sikes with a score of 268. Bobby Nickols, the pro at Firestone for many years, tied for fourth. Dick Sikes, the traveling man from Arkansas, is shown at right. (Courtesy of Lakewood C.C.)

70

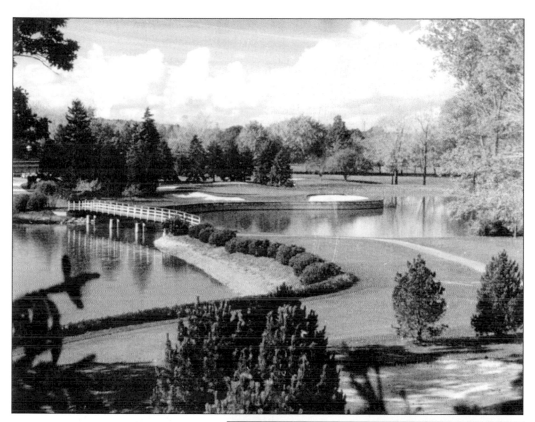

Lakewood Country Club's signature 16th hole, shown above, is a relatively short par 3 that stretches 156 yards from the back tee. This picturesque hole plays over water and is well bunkered. (Courtesy of Lakewood C.C.)

The Lakewood C.C. golf course was designed by A.W. Tillinghast, one of the top designers of all time. Surprisingly, Lakewood is the only course in Ohio that was originally designed by Mr. Tilllinghast. In 1930, he remodeled the Inverness Club in Toledo. Other major courses designed by A.W. Tillinghast include Baltusrol, the Black Course at New York's Bethpage State Park, Winged Foot, and Baltimore Country Club's Five Farms Course. Shown at right is A.W. Tillinghast. (Courtesy of the Tillinghast Association.)

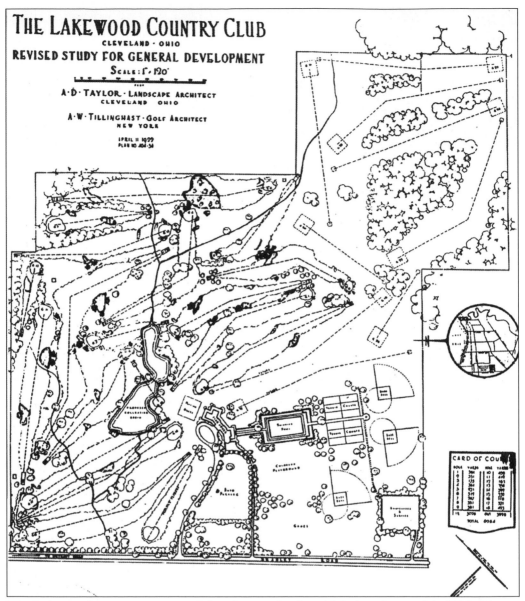

The Lakewood course was opened for play on the first 10 holes, August 24, 1923. Shown here is the Lakewood layout as designed by A.W. Tillinghast in 1922. (Courtesy of the Tillinghast Association.)

Jack Nicklaus played in the 1966 Cleveland Open at Lakewood C.C. and tied for 13th. The photo above shows Jack warming up at the practice range. (Courtesy of the "Choppy" Sage Collection at Lakewood C.C.)

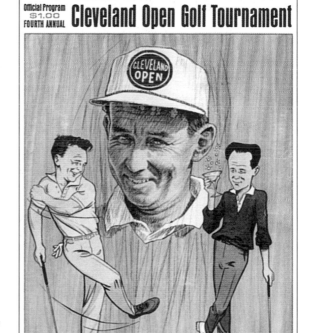

Official Program $1.00 FOURTH ANNUAL **Cleveland Open Golf Tournament**

LAKEWOOD COUNTRY CLUB AUGUST 1-7, 1966

The cover of the 1966 program of the Cleveland Open held at Lakewood C.C. shows the first three winners. Arnold Palmer, in caricature, is on the left. He won the first Cleveland Open at Beechmont in 1963. Tony Lema, also in caricature, is on the right. Tony won in 1964 at Highland Park. Dan Sikes Jr., in the middle, won in 1965, also at Highland Park. (Courtesy of Lakewood C.C.)

Arnold Palmer also participated in the 1966 Cleveland Open at Lakewood. Mr. Palmer won a total of 60 PGA Tour events, including three in 1966. He is shown here on the practice range at Lakewood. (Courtesy of the "Choppy" Sage Collection at Lakewood C.C.)

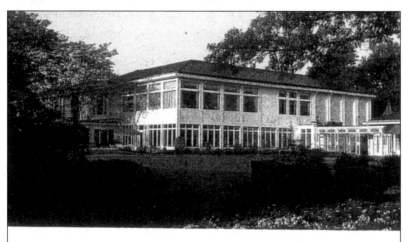

Lakewood Country Club

Lakewood has dedicated a room in their clubhouse, "The Tillinghast Room," and they are accumulating Tillinghast memorabilia. They also returned the course to the original design. Shown here is a modern picture of the clubhouse. (Courtesy of Lakewood C.C.)

Dave Stockton won the 1968 Cleveland Open with a total of 276. This was eight strokes higher than Dick Sikes' score in 1966 on the same Lakewood course. The course plays to 6,824 yards par 71 from the back tees per a recent scorecard shown here. (Courtesy of Lakewood C.C.)

A.W. Tillinghast-1921
Architect

THE AURORA COUNTRY CLUB AND THE CLEVELAND OPEN. The Aurora C.C. course was designed by Bert Way in 1926, according to the Cornish and Whitten book. It is currently listed in the 2004 Northern Ohio Golf Association directory at 6,642 yards. A score card from about 1969 is shown below. (Courtesy of Aurora C.C.)

SCORE CARD
Aurora Country Club
AURORA, OHIO

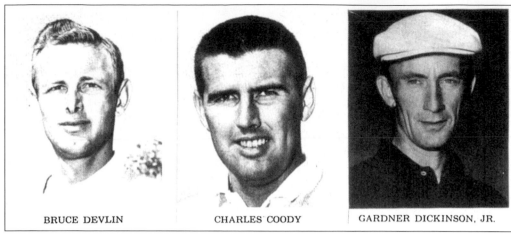

BRUCE DEVLIN CHARLES COODY GARDNER DICKINSON, JR.

Aurora C.C. hosted the Cleveland Open three times (1967, 1969, and 1970). The winner in 1967 was Gardner Dickenson Jr. with a score of 271. Charles Coody won in 1969, shooting 271 as well. The 1970 winner was Bruce Devlin with a score of 268. The second round was rained out in 1970 so the players had to complete 36 holes on Sunday. Tom Weiskopf was playing near where he grew up. He had a top ten finish. This was the week following the 1970 U.S. Open and Bruce Devlin had a top 10 finish in the Open, so he had some momentum going for him. Shown above are the three Aurora winners. (Courtesy of Aurora C.C.)

TANGLEWOOD COUNTRY CLUB AND THE LAST CLEVELAND OPEN. The Tanglewood C.C.'s course was only five years old when it hosted the 1972 Cleveland Open. Shown here is the cover for the 1972 tournament program. Tanglewood is a very challenging course, over 7,000 yards long with a slope of 145 from the championship tees. This is the highest slope in the Northern Ohio district. The winner in 1972 was David Graham with a score of 278, the highest winning total of the Cleveland Open series. In 1973, Canterbury hosted the PGA Championship, so this made it difficult to stage the Cleveland Open that year. Also, it seemed difficult to find a course willing to host the Cleveland Open. Whatever the reason, the Cleveland Open lasted just 10 years (1963–1972). However, it had some elite winners and noteworthy participation from the PGA Tour. (Courtesy of Tanglewood C.C.)

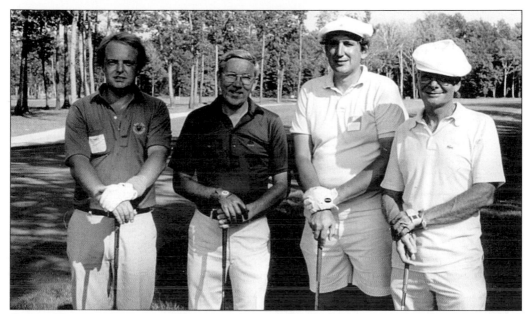

QUAILL HOLLOW RESORT AND COUNTRY CLUB. Originally known as Quail Hollow Inn and Golf Club, it had one 18-hole golf course that was designed by the team of Bruce Devlin and Robert Von Hagge. The course was opened in 1976. It has hosted two Ohio Opens and two U.S. Amateur Qualifiers. The author played in several outings at Quail Hollow including a couple that benefited the Boy Scouts. Shown here is our foursome for one of the Boy Scout Golf Benefits. Yours truly is second from the left. Others in the group were David Price, M.A. Keyes, and Kelly Sines.

Quail Hollow built a second 18-hole course with Tom Weiskopf and Jay Moorish as architects. This course opened in 1996 and plays to 6,872 yards from the back tees. The course hosted a USGA Senior Amateur Qualifier in 2002. Both Quail Hollow courses have been highly rated. Shown above is the scorecard for the Weiskopf-Moorish course. (Courtesy of Quail Hollow C.C.)

QUAIL HOLLOW INN & GOLF CLUB

11080 CONCORD-HAMBDEN ROAD
I-90 AND OHIO ROUTE 44
PAINESVILLE, OHIO 44077
216/352-6201 • 216/946-7990

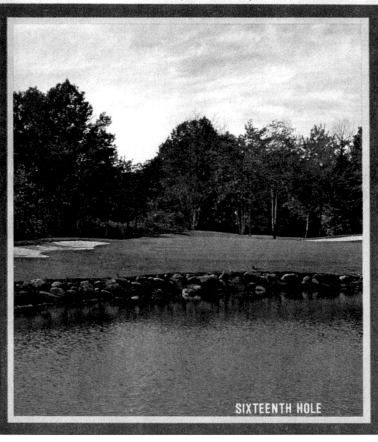

SIXTEENTH HOLE

QUAILL HALLOW AND THE GREATER CLEVELAND OPEN. The Quail Hollow Resort and Country Club hosted the Greater Cleveland Open from 1990 through 2001. These events were part of the "second" tour, which is called the Nationwide Tour in 2004. The first three years (1990–1992) it was the Ben Hogan Tour. From 1993 through 1999 it was the Nike Tour, and during 2000–2001 it became the Buy.com Tour. All the tournaments were played on the Devlin-Von Hagge course, which plays to 6,799 yards from the back tees. Shown at left is a vintage scorecard with a picture on its face of the 16th hole. Listed below are the winners.

1990	Barry Cheesman	1996	Greg Twiggs
1991	Jeff Gallagher	1997	Mike Small
1992	David Jackson	1998	Doug Dunakey
1993	Stan Utley	1999	Matt Gogel
1994	Tommy Armour III	2000	Dean Pappas
1995	Karl Zoller	2001	Heath Slocum

(Courtesy of Quail Hollow C.C.)

FIVE
Firestone and Canterbury

Firestone C. C. American Golf Classics—Firestone and the CBS Golf Classics—Firestone Commeratives—Firestone's North Course—Firestone C.C. The West Course—Senior Tournament Players Championship—Ameritech Senior Open at Canterbury—Firestone and The World Series of Golf

PRESS BOOK

FIRESTONE COUNTRY CLUB
Akron, Ohio

August 5-11, 1968

FIRESTONE C. C. AMERICAN GOLF CLASSICS. Jay Hebert beat Gary Player in a playoff for the first American Golf Classic in 1961. Hebert won the PGA Championship the year before. Arnold Palmer was the only two-time winner. Shown at right is the cover of the 1968 Press Book for the American Golf Classic. (Courtesy of Firestone C.C.)

YEAR	WINNER	SCORE
1961	Jay Hebert	278
1962	Arnold Palmer	276
1963	Johnny Pott	276
1964	Ken Venturi	275
1965	Al Geiberger	280
1966	(Not held due to hosting the PGA Championship)	
1967	Arnold Palmer	276
1968	Jack Nicklaus	280
1969	Ray Floyd	268
1970	Frank Beard	276
1971	Jerry Heard	275
1972	Bert Yancy	276
1973	Bruce Crampton	273
1974	Jim Colbert	281
1975	(Not held due to hosting the PGA Championship)	
1976	David Graham	274*

*Played on the North Course

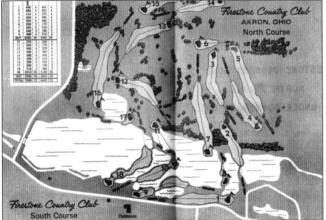

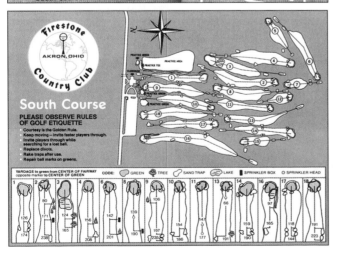

As noted in the list of winners, the last Classic (1976) was played at the North Course. The North Course was designed by Robert Trent Jones and opened in 1969. It plays at 7,060 yards from the back tees. The layout is shown left. (Courtesy Firestone C. C.)

FIRESTONE AND THE CBS GOLF CLASSIC. Firestone C.C. also hosted a series of tournaments called the CBS Golf classics. This series was primarily a made-for-television tournament. It ran for eight years, from 1967 to 1974. It occurred during years in which the American Golf classics and the World Series of Golf were also being hosted. As noted in the following chart of winners, it was a two-man team competition except for the final year in 1974 when it changed to an individual tournament. At left is the back of the scorecard for the South Course and from the era of the CBS Golf Classics. (Courtesy Firestone C.C.)

FIRESTONE C. C. CBS GOLF CLASSICS

YEAR	WINNER
1967	Sam Snead & Gardner Dickinson
1968	Al Geiberger & Dave Stockton
1969	Al Geiberger & Dave Stockton
1970	Gene Littler & Ken Still
1971	Tom Weiskopf & Bert Yancy
1972	Gene Littler & Miller Barber
1973	Jerry Heard & Lanny Wadkins
1974	Lanny Wadkins

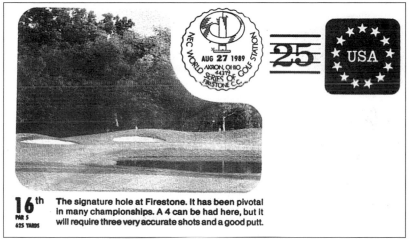

16th PAR 5 625 YARDS The signature hole at Firestone. It has been pivotal in many championships. A 4 can be had here, but it will require three very accurate shots and a good putt.

FIRESTONE COMMEMORATIVES. This postal envelope commemorates the 1989 NEC World Series of Golf at Firestone C.C. The cachet is of the 16th hole, called the "monster" by Arnold Palmer in an earlier tournament. It's the signature hole at Firestone's South Course, a par 5 at 625 yards.

3rd PAR 4 442 YARDS Downhill dogleg right requires an excellent tee shot to the left side of the fairway. The small green is surrounded by three well-placed bunkers and requires a very delicate approach shot.

The following year another postal commemorative envelope was issued. This time the cachet shows the par 4 No. 3 hole that also has water in front of the green and is well bunkered. The golf ball-shaped cancellation shows a trajectory line to the "green" in the cachet, a clever connection. A separate envelope with the appropriate date was issued for each day of the tournament.

FIRESTONE'S NORTH COURSE. The North Course at Firestone was designed by Robert Trent Jones and opened in 1969. It has more holes where water comes into play than the South Course. The North Course was the site for the 1976 American Golf classic and the 1994 NEC World Series of Golf. The picture at left is the cover for the 1994 tournament program. Fulton Allem was the defending champion, but Jose Maria Olazabal was the 1994 winner. (Courtesy of Firestone C.C.)

West Course

FIRESTONE'S WEST COURSE. The Firestone West Course was originally designed by Geoffrey Cornish and Brian Silva and opened in 1989. About 10 years later it was closed for redesign, with legendary architect Tom Fazio heading the project. It was reopened for play in 2002. The West Course is the third Firestone course and all are championship caliber. Firestone's website refers to it as the home of the Ohio Senior Open. The scorecard above is of the era of the course's original design, when the writer played there in 1990. (Courtesy Firestone C.C.)

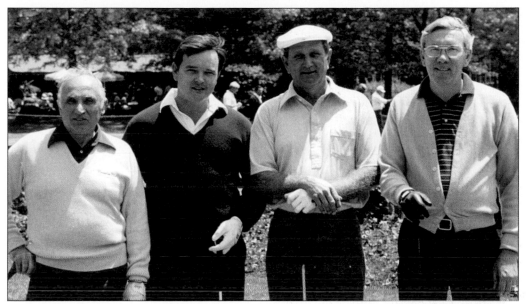

SENIOR TOURNAMENT PLAYERS CHAMPIONSHIP. The inaugural Senior Players Championship was held at Canterbury in 1983. This author played in the Pro-Am. Our pro participant was Bert Weaver. He was friendly and played well. The photo above is our team, from left to right, as follows: R. Colosimo, D. Noland, Bert Weaver, and yours truly.

The winner of the 1st Senior TPC was Miller Barber. He shot 278, just one better than runner-up Gene Littler. Many famous players participated including three who were already members of the World Golf Hall of Fame with a total of 196 tour titles including 17 majors—Sam Snead, Arnold Palmer, and Billy Casper. Shown above is the special hole flag for the First Senior TPC tournament. (Courtesy of Canterbury G.C.)

This pairings sheet shows Canterbury's par 3, third hole which played at 165 yards. The green is well bunkered and has water in front, which does not come into play. There is a small stream that crosses three holes but water is not a problem at Canterbury. The three finishing holes usually determine the winner. In 1983, Littler had a two-shot lead going into No. 17, but double bogied from the sand, and then Miller Barber birdied No. 18 to win. (Courtesy of Canterbury G.C.)

When the 1984 Senior TPC at Canterbury rolled around Miller Barber, the '83 winner came a month early to test the course. Joining Miller was Dan Sikes, Senior PGA Tour Director Brian Henning, and Bob Goalby. (Photo courtesy of Sun Newspapers.)

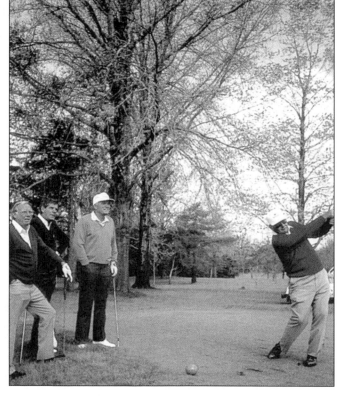

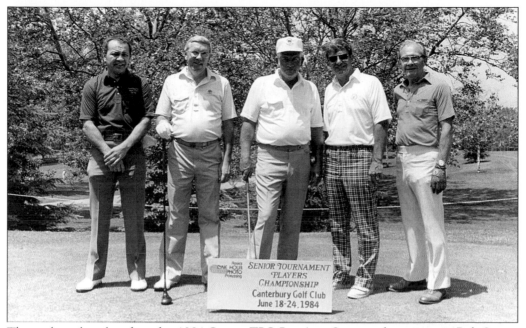

The author also played in the 1984 Senior TPC Pro-Am. Our pro this time was Bob Stone, whose claim to fame was a tie with Arnold Palmer and Billy Casper in the 1981 U.S. Senior Open, which Palmer won in the playoff. Our team, pictured above, left to right, was Archie Berry, Ken Hopkins, Bob Stone, Dick Caser, and Dave W. Jones.

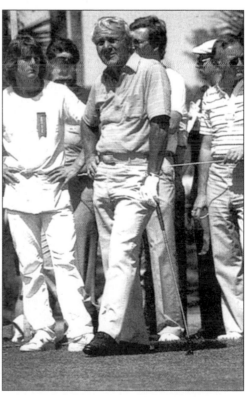

Arnold Palmer won the '84 Senior TPC with a score of 276. Peter Thomson was the runner-up at 279. Palmer also won the 1985 tournament, shooting 274, which was eleven strokes better than second place. There was a four-way tie for second at 285 between Miller Barber, Lee Elder, Gene Littler, and Charles Owens (who plays cross-handed and has a bad knee from a parachute jump while in the military). The photo at right shows Palmer as he waits to play his shot. (Courtesy Canterbury G.C.)

The Senior TPC players had only praise for the Canterbury course. It is always in excellent condition. The fairway grass is so perfect the player always has the best lie possible. The course has several dogleg holes, the greens are difficult to putt due to the speed and contours, the fairways are tree-lined, and the overall length is challenging. All in all, Canterbury is a difficult but fair course. The members are very proud of their course. The 1984 pairing sheet at left shows the Canterbury crest. (Courtesy of Canterbury G.C.)

The 1986 Senior TPC at Canterbury was beset with weather problems and the tournament had to be shortened to 54 holes. This picture is the cover of the 1986 program. It depicts an old-time golfer from the early Twenties when the club opened. The grand clubhouse is in the background. (Courtesy of Canterbury G.C.)

Chi Chi Rodriguez was the winner of the 1986 Senior TPC with a score of 206. Bruce Crampton was the runner-up at 208. Starting in 1993 the tournament is called the Ford Tournament Player Championship and it remains a major tournament for the senior players. The trophy, shown at right, is called the Sam Snead Memorial Trophy and is made up of medals that Sam won over the 50 or so years of his play. (Courtesy of Canterbury G.C.)

**Senior Tournament Players Championship
Canterbury Golf Club
June 18-22, 1986**

AMERITECH
SENIOR OPEN
CANTERBURY GOLF CLUB
CLEVELAND, OHIO

GOOD THIS DATE ONLY
FRIDAY, JULY 21, 1989

ADMISSION $15.00 NO REFUND

TICKET MUST BE DISPLAYED

RELEASE OF LIABILITY
This ticket is sold upon the express agreement that the holder thereof is aware of and assumes all risks of bodily injury or property damage, including specifically (but not exclusively) the risks of being injured by thrown or struck golf balls or clubs, actions by other spectators, players, caddies or others in attendance, and the holder agrees that the Western Golf Association, Canterbury Golf Club, PGA Tour, Ameritech, and its affiliates and the individual golfers are not liable for any injuries or property damage resulting from such causes or any other negligence.

02174

AMERICAN SENIOR OPEN AT CANTERBURY. The first year for the Ameritech Senior Open was 1989 and it was hosted by Canterbury Golf Club. The winner was Bruce Crampton with a score of 205 for this 54-hole tournament. Jim Ferree and Orville Moody tied for second with scores of 206. Shown at left is a ticket for the first round. (Courtesy of Canterbury G.C.)

Pairings & Starting Times 50¢
July 17-23, 1989

AMERITECH
SENIOR OPEN

Canterbury Golf Club

HOLE	1	2	3	4	5	6	7	8	9	OUT	10	11	12	13	14	15	16	17	18	IN	TOTAL
YARDS	430	348	185	410	380	508	175	382	525	3333	352	185	272	490	366	396	580	210	391	3282	6615
PAR	4	4	3	4	4	5	3	4	5	36	4	3	4	5	4	4	5	3	4	36	72

Concessions
4th Fairway
13th Green
15th Green
16th Tee
18th Green

Port-O-Lets
4th Fairway
6th Green
8th Fairway
11th Green
13th Tee
15th Green
18th Green

EPSON **Visit the Epson Official Computerized Scoring Tent** located at the crossroads between the Hospitality Area and the 18th Green and receive a printout of the following: ESi

- Leaderboard
- Leader Score Cards
- Course Analysis
- Individual Score Cards
- Player I.D. Number
- Leader Round by Round Totals
- Group Score Cards

Epson is the Official Computer Products Company of the Ameritech Senior Open,
PGA Tour, Senior PGA Tour, and PGA of America.

The course played at 6,615 yards (less than its full length) for the Ameritech Senior Open. Canterbury had previously hosted the Senior Tournament Players Championship from 1983 through 1986. 1983 was also the first of the Senior Players championship events. Shown at left is the pairing sheet showing the course layout. (Courtesy of Canterbury G.C.)

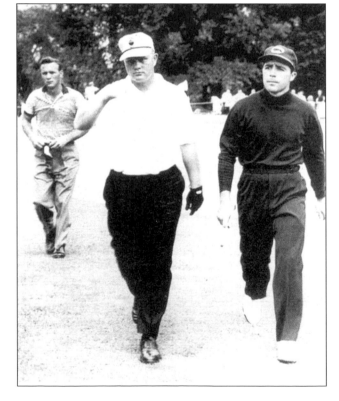

FIRESTONE AND THE WORLD SERIES OF GOLF. It's hard to believe that the World Series of Golf and its successors have been going on for over 40 years. It started in 1962 as a two-day event for the four major championship winners. Jack Nicklaus won it five times, four under the original format and then again in 1976 when it became a larger field event. The photo at right shows Arnold Palmer, Jack Nicklaus, and Gary Player, the participants in the 1962 event. (Courtesy of Firestone C.C.)

Shown at right is the cover for the 1971 tournament. Bruce Crampton, winner of the Western Open, was added to the field that year since Lee Trevino won both the U.S. and British Opens. The other participants were Charles Coody (Masters) and Jack Nicklaus (PGA). Coody was the 1971 winner. (Courtesy of Firestone C.C.)

NEC became the title sponsor of the World Series of Golf in 1984. The tournament remained the NEC World Series of Golf through 1998. The picture at left is the cover of the 1984 program. (Courtesy of Firestone C.C.)

2001 NEC INVITATIONAL
OFFICIAL MAGAZINE

August 21-26, 2001
Firestone Country Club
Akron, Ohio

NEC

Starting in 1999 the NEC World Series of Golf became part of the World Golf Championships and the new name is the NEC Invitational. The number of players increased also. Tiger Woods won the first three years in the new format. The picture at left is the cover of the 2001 NEC Invitational program showing Tiger in the previous year's event, which he won by 11 strokes. (Courtesy of Firestone C.C.)

Listed below are the winners, year by year, and their scores, starting with the first World Series of Golf in 1962 and going through the NEC World Series and to the NEC Invitational of 2003. The 2002 event was held at Sahalee C.C. due to Firestone hosting the Senior PGA Championship. Craig Perry won the 2002 NEC Invitational at Sahalee.

FIRESTONE COUNTRY CLUB WORLD SERIES OF GOLF

YEAR	WINNER	SCORE	YEAR	WINNER	SCORE
1962	JACK NICKLAUS	135	1984	DENIS WATSON	271
1963	JACK NICKLAUS	140	1985	ROGER MALTBIE	268
1964	TONY LEMA	138	1986	DAN POHL	277
1965	GARY PLAYER	139	1987	CURTIS STRANGE	275
1966	GENE LITTLER	143	1988	MIKE REID	275
1967	JACK NICKLAUS	144	1989	DAVID FROST	276
1968	GARY PLAYER	143	1990	JOSE M. OLAZABAL	262
1969	ORVILLE MOODY	141	1991	TOM PURTZER	279
1970	JACK NICKLAUS	136	1992	CRAIG STADLER	273
1971	CHARLES COODY	141	1993	FULTON ALLEM	270
1972	GARY PLAYER	142	1994	JOSE M. OLAZABAL	269*
1973	TOM WEISKOPF	137	1995	GREG NORMAN	278
1974	LEE TREVINO	139	1996	PHIL MICKELSON	274
1975	TOM WATSON	140	1997	GREG NORMAN	273
1976	JACK NICKLAUS	275	1998	DAVID DUVAL	269
1977	LANNY WADKINS	267	1999	TIGER WOODS	270
1978	GIL MORGAN	278	2000	TIGER WOODS	259
1979	LON HINKLE	272	2001	TIGER WOODS	268
1980	TOM WATSON	270	2002	(Held at Sahalee C.C. due to hosting Sr. PGA Championship)	
1981	BILL ROGERS	275	2003	DARREN CLARKE	268
1982	CRAIG STADLER	278			
1983	NICK PRICE	280			

*Played on North Course

Six
Major Championships

Canterbury and the U.S. Open—Canterbury Hosts the 1973 PGA Championship—Firestone
Hosts Three PGA Championships—1996 U. S. Senior Open at Canterbury—Firestone Hosts
the 63rd Senior PGA Championship—Bobby Jones Commemorative—Ben Curtis

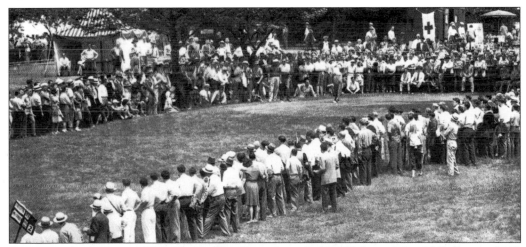

CANTERBURY AND THE U.S. OPEN. The Canterbury Golf Club hosted two U.S. Opens, 1940 and 1946. Both years, the tournament resulted in a tie with subsequent playoffs. The 1940 tournament was won by Lawson Little, 70-73, over Gene Sarazen in an 18-hole playoff. Ed "Porky" Oliver would have been in the playoff, but was disqualified for starting the final round too early. He and others tried to beat an impending storm and all were disqualified. 1940 was also the final appearance of Walter Hagen in a U.S. Open. Typically, he showed up late for the start of the third round, barely getting to tee off with his group which had already hit away. Sam Snead was tied for the lead after three rounds, but shot a horrendous final round, 81 to tie for 16th. The photo above is a scene from the 1940 U.S. Open. (Courtesy of Canterbury G.C.)

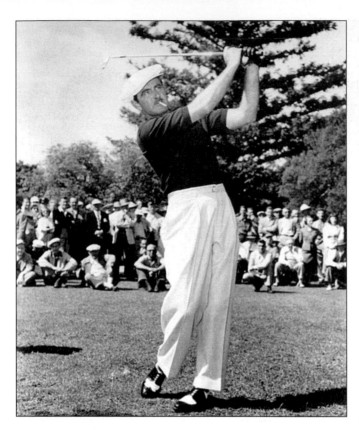

The 1941 U.S. Open was played at Colonial C.C. in Fort Worth, TX. The 1942 through 1945 Opens were cancelled due to World War 2. The USGA returned to Canterbury G.C. for the 1946 U.S. Open. This time the tournament ended in a three-way tie between Lloyd Mangrum, Byron Nelson, and Vic Ghezzi, all at 284. They all tied again after one 18-hole play off, necessitating a second 18-hole playoff, which Mangrum, pictured here, won with a 72 to the others at 73. (Courtesy of the Northern Ohio Golf Association.)

Official Score Card

Forty-Sixth Open Championship
of the United States Golf Association

Canterbury Golf Club
Warrensville, Ohio

June 13, 14 and 15, 1946

Canterbury has arguably the finest three finishing holes in golf. No. 16 plays at 615 yards and is almost never reached in two shots. No. 17 is 235 yards to an elevated green, and No. 18 is 441 yards uphill. The players had considerable difficulty with these finishing holes. The official scorecard for the 1946 U.S. Open is shown above.

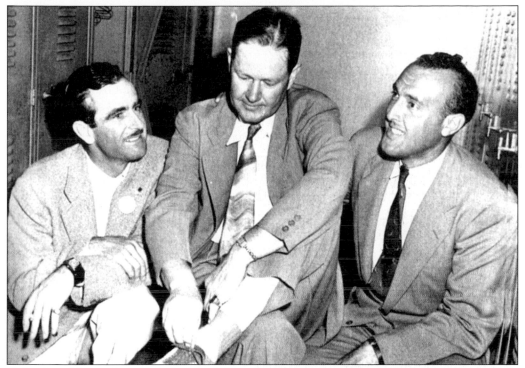

Nelson's caddy accidentally kicked his ball in the third round of the 1946 U.S. Open on the 15th hole. The one stroke penalty could have cost him the title. The locker room photo shows Nelson's displeasure with the outcome. Also shown are Lloyd Mangrum on the left and Vic Ghezzi on the right. Ghezzi and Nelson lost the play off to Mangrum. (Courtesy Canterbury G.C.)

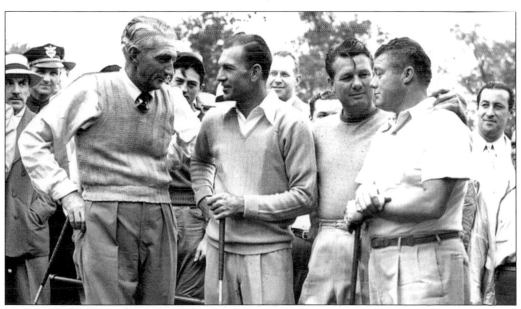

This vintage photo of Tommy Armour, Ben Hogan, Jimmy Demaret, and Lawson Little was from the time of the 1946 Open in which they all played. They all finished in the top 10 except Armour, who missed the cut. (Courtesy of the Northern Ohio Golf Association.)

CANTERBURY HOSTS THE 1973 PGA CHAMPIONSHIP. The 55th (1973) PGA Championship was hosted by the Canterbury Golf Club. This was the sixth major championship to be held at Canterbury. The club had previously been the site for two Western Opens, two U.S. Opens, and one U.S. Amateur. Another U.S. Amateur was held in 1979. At left is the cover of the program showing the Wanamaker Trophy with a special bag tag for the event. (Courtesy of Canterbury Golf Club.)

Jack Nicklaus went into the final day with a one-stroke lead over Mason Rudolph and Don Iverson. Bruce Crampton was three back but was the eventual runner-up. Nicklaus was the winner with a score of 277. He shot 69 in the final round. Shown at right is a ticket for the final round of the tournament. (Courtesy of Canterbury G.C.)

Firestone Country Club
AKRON · OHIO

HOLE BY HOLE YARDAGE	Hole	Par	Yards	Hole	Par	Yards	
	1	4	400	10	4	405	
	2	5	500	11	4	365	
	3	4	450	12	3	180	TOTAL 35-35 - 70
	4	4	465	13	4	460	
	5	3	230	14	4	410	
	6	4	465	15	3	230	7,180 YARDS
	7	3	225	16	5	625	
	8	4	450	17	4	390	
	9	4	465	18	4	465	
	Total	35	3650	Total	35	3530	

FIRESTONE HOSTS THREE PGA CHAMPIONSHIPS. Firestone was the first to host three PGA Championships (1960, 1966 and 1975). Before the 1960 tournament, Robert Trent Jones was called in to strengthen the course. He lengthened the "South" course from 6,585 yards and par 71 to 7,180 yards and par 70. However, he kept the same basic layout as originally designed by Bert Way. Added also were 50 bunkers and two lakes. The South Course layout above is from an American Golf Classics booklet. (Courtesy of Firestone C.C.)

Jay Hebert won the 1960 tournament with a score of 281. Jim Ferrier was runner-up. The photo at right shows Doug Sanders hitting from the rough at the 1960 Championship. Sanders played well and finished tied for third with Sam Snead at 283. (Courtesy of the Northern Ohio Golf Association.)

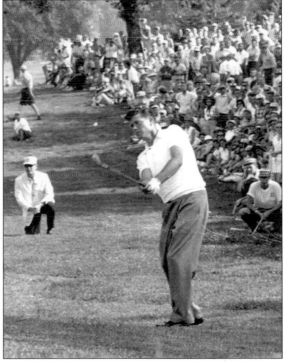

The 1966 PGA at Firestone was the 50th Anniversary championship. The PGA was organized and held its first tournament in 1916, won by Jim Barnes. Al Geiberger won the 1966 tournament with a score of even par-280. Dudley Wysong was the runner-up. Sam Snead finished in the top ten at age 54. Geiberger also won the 1965 American Golf Classic, and in partnership with Dave Stockton won the 1968 and 1969 CBS Golf Classics. This photo of Geiberger is from the 1975 program. (Courtesy of Firestone C.C.)

The third PGA Championship at Firestone was held in 1975, and the winner was Jack Nicklaus with a score of 276. Jack had previously won the 1973 PGA Championship at Canterbury in Cleveland. Both times the runner-up was Bruce Crampton. Nicklaus also won the 1968 American Golf Classic at Firestone and he was a five-time winner of the World Series of Golf, for a total of seven wins at Firestone. The cover of the 1975 PGA Championship program is shown at right. (Courtesy of Firestone C.C.)

The 1975 win was Nicklaus' fourth of five PGA championship victories. Jack is shown here with the Wanamaker trophy. (Courtesy of Firestone C.C.)

1996 U.S. SENIOR OPEN AT CANTERBURY. Canterbury Golf Club hosted the 1996 U.S. Senior Open Championship. The opening round was on the Fourth of July, as shown on this ticket. (Courtesy of Canterbury G.C.)

All the previous winners of professional tournaments at Canterbury since the 1973 PGA were present in the field of players. This included Jack Nicklaus, Arnold Palmer, Miller Barber, Chi Chi Rodriguez and Bruce Crampton. Shown at left is the pairing sheet for the opening round. (Courtesy of Canterbury G.C.)

U.S. SENIOR OPEN CHAMPIONS

YEAR	WINNER, RUNNERS-UP	SCORE
1980	**Roberto De Vicenzo**	285
	a-William C. Campbell	289
1981	**Arnold Palmer**	289-70
	Bob Stone	289-74
	Billy Casper	289-77
1982	**Miller Barber**	282
	Gene Littler	286
	Dan Sikes, Jr.	286
1983	**Billy Casper**	288-75-3
	Rod Funseth	288-75-4
1984	**Miller Barber**	286
	Arnold Palmer	288
1985	**Miller Barber**	285
	Roberto De Vicenzo	289
1986	**Dale Douglass**	279
	Gary Player	280
1987	**Gary Player**	*270
	Doug Sanders	276
1988	**Gary Player**	288-68
	Bob Charles	288-70
1989	**Orville Moody**	279
	Frank Beard	281
1990	**Lee Trevino**	275
	Jack Nicklaus	277
1991	**Jack Nicklaus**	282-65
	Chi Chi Rodriguez	282-69
1992	**Larry Laoretti**	275
	Jim Colbert	279
1993	**Jack Nicklaus**	278
	Tom Weiskopf	279
1994	**Simon Hobday**	274
	Graham Marsh	275
	Jim Albus	275
1995	**Tom Weiskopf**	275
	Jack Nicklaus	279

Dave Stockton was the winner of the 1996 U.S. Senior Open at Canterbury. Dave's score was 277 and the runner-up was Hale Irwin. They join the list of previous winners as shown here. (Courtesy Canterbury G.C.)

FIRESTONE HOSTS THE 63RD SENIOR PGA CHAMPIONSHIP. The 63rd Senior PGA Championship was held at Firestone C.C., June 6–9, 2002. The program cover is shown at right. (Courtesy Firetone C.C.)

The winner of the 2002 Senior PGA was Fuzzy Zoeller. His score was 278, or two under par. This was his first win as a senior and it was a major senior championship. Fuzzy had 10 wins on the regular tour. At left is a picturesque ticket issued for the tournament. (Courtesy of Firestone C.C.)

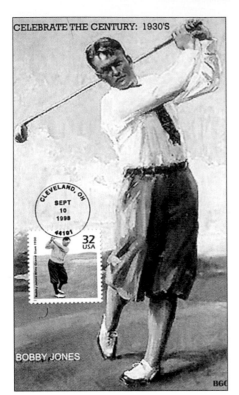

CELEBRATE THE CENTURY: 1930'S

CLEVELAND, OH
SEPT
10
1998
44101

32
USA

BOBBY JONES

BGC

BOBBY JONES COMMEMORATIVE. This postal cover was issued in Cleveland in 1998 as part of the USPS Celebrate the Century Series for the 1930s. It was in 1930 that Bobby Jones won the Grand Slam. As an amateur, he won the U.S. Open and U.S. Amateur, plus the British Open and British Amateur all in the same year. He retired from competitive golf soon after completing this unique achievement. Bobby Jones competed in at least one Cleveland tournament, the 1921 Western Open. He finished fourth, at age 19.

BEN CURTIS. Northeast Ohio claims the 2003 British Open Champion, Ben Curtis, as its own. He resides in the area and was a three-time All-American college golfer at Kent State University. Ben also won the Ohio Amateur in 1999 and 2000. He qualified for three U.S. Amateurs (1997–1999) and was a semifinalist in 1999. The photo at right shows Ben after being medalist in the local U.S. Amateur qualifier in 1999. (Courtesy of the Northern Ohio Golf Asssociation.)

Opposite: **U.S. AMATEUR PUBLIC LINKS IN CLEVELAND.** Ridgewood Golf Club hosted the 1927 U.S. Amateur Public Links Championship. Carl Kauffman defeated William Serrick one up in the final. Ridgewood Golf Club has undergone some changes since 1927. Four or five holes have changed due to residential development. Other holes have been lengthened. The course is now owned by the city of Parma, one of Cleveland's many suburbs. The 1938 U.S. Amateur Public Links Championship was held at Highland Park Municipal Golf Course. Al Leach, a native Clevelander, defeated Louis Cyr one up in the final. Walter Burkemo was the medalist. "Highlands" has 36 holes and, along with Seneca Golf Courses, also 36 holes, is owned and operated by the City of Cleveland. The Highland Park Golf Course was opened for play about 1915. Shown opposite is a scorecard for the Ridgewood Golf Club from about 1970. (Courtesy of Ridgewood G.C.)

SEVEN

Amateur Players
and Championships

U.S. Amateur Public Links in Cleveland—The 1934 National Intercollegiate Golf Championship at The Country Club— 1935 U. S. Amateur Held at The Country Club —U.S. Amateurs Held at Canterbury —Palmer Wins City Tournament—Northern Ohio Golf Association—Ed Preisler—Robert Lewis Jr.—Mary Ann Bierman

1934 NATIONAL INTERCOLLEGIATE GOLF CHAMPIONSHIP AT THE COUNTRY CLUB. The Country Club hosted the 1934 college championship, which at that time was under the auspices of the U.S.G.A. Shown here is the cover of the program. (Courtesy of The Country Club.)

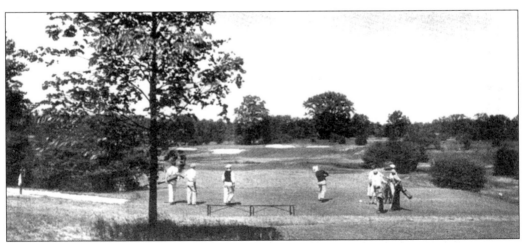

The National Intercollegiate Golf Championship dates back to 1897, and early on it was dominated by Ivy League players. However, the 1933 winner was Walter Emery from the University of Oklahoma, and the 1934 winner, at The Country Club, was Charles Yates of Georgia Tech. The William Flynn-designed course was a worthy test of the college players' mettle. The photo shown here of the 14th hole is from the 1935 program. (Courtesy of The Country Club.)

1935 U.S. Amateur at The Country Club.
The 1935 U.S. Amateur was hosted by The Country Club and it was all match play. There were 26 sectional qualifying sites where 36 holes were played to determine the field of players for the championship. Beechmont was a qualifying site. The cover of the competition announcement is shown here. (Courtesy of The Country Club.)

THIRTY-NINTH COMPETITION

for the

AMATEUR CHAMPIONSHIP

of the

UNITED STATES GOLF ASSOCIATION

•

SEPTEMBER 9-14

inclusive

1935

•

THE COUNTRY CLUB
CLEVELAND, OHIO

One of the finalists was a young sharpshooter out of the University of Oklahoma who had won the Intercollegiate Championship in 1933, Walter Emery. Emery knew the course, having participated in the 1934 collegiate tournament at "Country." (Courtesy of the Northern Ohio Golf Association.)

The other finalist was W. Lawson Little Jr. The leading amateur of his time, Mr. Little defeated Emery, 4 and 2, at The Country Club in Cleveland. (Courtesy of the Northern Ohio Golf Association.)

The 1935 U.S. Amateur victory by Lawson Little completed an amazing achievement. He accomplished the "Little Slam" by winning both the U.S. and British Amateurs in back-to-back seasons, 1934 and 1935. Little closed out the 1935 win with a birdie-eagle finish on the 33rd and 34th holes. (Courtesy of The Country Club.)

FINAL ROUND OF THE
THIRTY–NINE NATIONAL AMATEUR GOLF CHAMPIONSHIP TOURNAMENT
OF AMERICA

Held at The Country Club, Cleveland, Ohio
September 9-14th, 1935

HOLE	1	2	3	4	5	6	7	8	9	OUT	10	11	12	13	14	15	16	17	18	IN	OUT	TOTAL	
LONG COURSE	354	467	315	325	200	416	465	520	148	3210	381	164	588	390	184	417	512	383	413	3432	3210	6642	
SHORT COURSE	354	467	315	325	180	416	436	520	148	3161	381	141	588	390	164	417	493	340	390	3304	3161	6465	
PAR	4	5	4	4	3	4	4	5	3	36	4	3	5	4	3	4	5	4	4	36	36	72	
Lawson Little	4	5	5	4			3	4	5	3	36	4	3	5	4	3	3	5	4	5	36	72	All Even
Walter Emery	3	4	4		3	4	4		3	35	4	3	5	5	5	5	4	4	31	73			
W-L-H		(Little, 3 Down)																					
Lawson Little	4	5	3		3	4		5	3	34	4	4	5	4	3	3	3					A 4	
Walter Emery	4	5	4		2	5	5	3	36	5	3	4	4	4	5	4							
HANDICAP	11	4	14	13	15	6	5	2	17		9	18	1	10	16	7	3	12	8				
SCORER	Walter Emery						STYMIE MEASURE		Lawson Little Jr.										DATE 9/14/35				

This was the thirty-first consecutive match won by Mr. Little in British National Amateur Championship and American National Amateur Championship play. By this victory he became holder of both the British and the American titles for the second consecutive year.

U.S. AMATEUR HELD AT CANTERBURY. The Canterbury Golf Club has hosted two U.S. Amateurs, 1964 and 1979. The 1964 final match was between William Campbell and Edgar M. Tutwiler. Bill Campbell shown here won the match one up. Mr. Campbell qualified for the U.S. Amateur 37 times and played in 15 U.S. Opens and 18 Masters. Born in West Virginia in 1923, he became the USGA president in 1982, and later was only the third American to be elected Captain of the Royal and Ancient. Bill Campbell won many local and regional amateur tournaments, but this was his only win in the U.S. Amateur. He has had a long and distinguished career in golf. (Courtesy Northern Ohio Golf Association.)

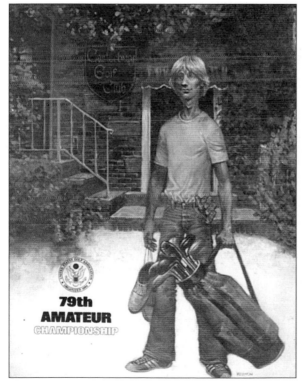

The 1979 U.S. Amateur final became a duel between John Cook and Mark O'Meara both of whom became highly successful and popular Tour professionals. John Cook won this tournament the year before. 1979 was Mark O'Meara's turn, winning over John Cook in the final, 8 and 7. Pictured here is the cover of the program for the 79th Amateur Championship. (Courtesy of Canterbury Golf Club.)

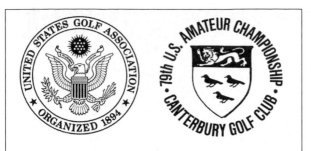

79th U.S. Amateur Championship
conducted by:

United States Golf Association

Qualifying Rounds
sponsored by:

Canterbury Golf Club/Shaker Heights Country Club

Medal Play starting times only
Tues., Aug. 28th Wed., Aug. 29th

Match Play
Thurs., Aug. 30th — Sunday, Sept. 2nd
Canterbury Golf Club
Beachwood / Shaker Heights, Ohio

Qualifying rounds for the 1979 U.S. Amateur were held at both Canterbury and nearby Shaker Heights clubs. The 64 top medalists then participated in match play at Canterbury. Some other players in this group who became successful on the PGA Tour included Bob Clampett (the medalist), Gary Halberg, Bob Tway, Jodie Mudd, Hal Sutton, Scott Hoch, Payne Stewart, and Fred Couples. Shown here is the pairing sheet for the qualifying rounds. (Courtesy of Canterbury Golf Club.)

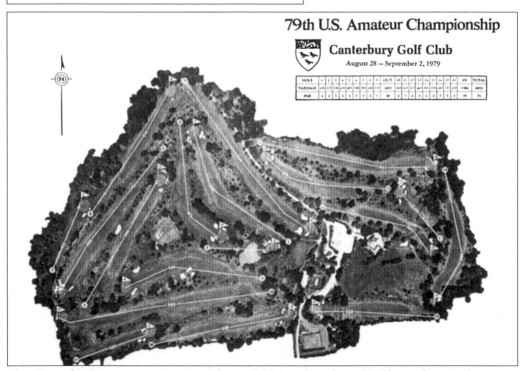

The Canterbury course was set up to play at 6,852 yards and par 71. Shown here is the course layout. In 1979, Canterbury was rated in the top 50 of America's best golf courses. The course was designed by Herbert Strong and opened for play in 1921. The competitive course record at that time was 67, set by Sam Snead and others. (Courtesy of Canterbury Golf Club.)

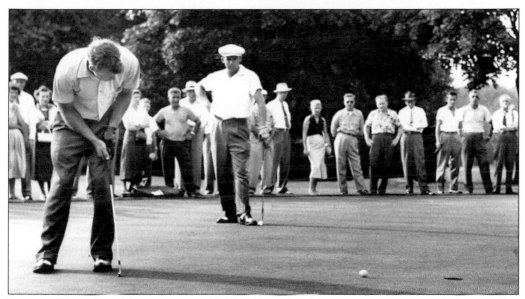

PALMER WINS CITY TOURNAMENT. A Cleveland City tournament starting in 1931 was called the Plain Dealer Cup. This championship was for amateurs playing at local golf courses. The above photo shows Arnold Palmer sinking a seven-foot putt to win the 1953 event with a winning score of 280. The finals that year were at Shaker Heights C.C. Palmer was stationed in Cleveland while in the Coast Guard in 1953 and 1954 and won the Ohio Amateur in both those years. He played mostly at Pine Ridge C.C., but at other local courses as well. Palmer joined the PGA Tour in 1955. (Courtesy of the Northern Ohio Golf Association.)

NORTHEN OHIO GOLF ASSOCIATION. The Northern Ohio Golf Association has roots going back to 1917 when the first organizational meeting was held to form the Cleveland District Golf Association. The first member clubs were Country, Dover Bay, Highland Park, Mayfield, Oakwood, Shaker Heights, Westwood, and Willowick. In 2004, there are 49 member clubs. The name was changed in 1981 to The Northern Ohio Golf Association (NOGA). The Executive director for the past 10 years is Robert A. Wharton and the Associate Director is Kathy MacGregor Shankleton. Bob Wharton was honored recently for his vision and leadership in several NOGA endeavors including the new headquarters building. The picture at right shows Bob being honored. (Courtesy of the Northern Ohio Golf Association.)

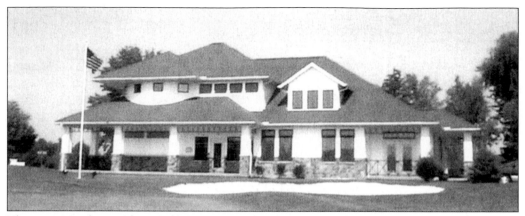

The new Northern Ohio Golf Association headquarters building has been named the Bob Wharton Golf Center. In addition to offices for the staff, the building includes a Hall of Fame room, library and conference room, and a second floor area for museum and archives. Shown above is the view of the building from the North Olmsted Golf Club's ninth green. (Courtesy of the Northern Ohio Golf Association.)

A golf teaching facility is one element in the Bob Wharton Golf Center, located in the basement of the building as shown here. (Courtesy Northern Ohio Golf Association.)

The Northern Ohio Golf Association also acquired the nine-hole par 3 North Olmsted Golf Club. The course is open to the public and many adults, especially seniors, use the course. However, the facility also caters to junior players and golfers with disabilities. The picture above shows some of the golfers with disabilities practicing. (Courtesy of NOGA.)

ED PREISLER. Preisler was an outstanding amateur golfer in northeast Ohio for a long time. Mr. Preisler won the Ohio Amateur in 1946, the Ohio Mid-Amateur in 1964, and the Ohio Senior Amateur in 1967. He was a "plus 3" handicap in his prime and was selected as a charter member of the Ohio Golf Hall of Fame in 1992, and among the NOGA Hall of Fame's inaugural members in 2003. He won six Cleveland District (now NOGA) Championships. He had shot his age every year from ages 68 to 90. A member of Beechmont C.C. for almost 60 years, he had devoted time and support to the Society for Crippled Children and to the Northern Ohio Caddie Scholarship Foundation. He had a close friendship with Arnold Palmer, dating back to Arnold's amateur days in Cleveland. One of Mr. Preisler's proudest accomplishments was his 10 medals won in Israel's Maccabiah Games. Mr. Preisler passed away in July 2004. Shown at right is Mr. Preisler receiving the NOGA award in 2003. (Courtesy of the Northern Ohio Golf Association.)

ROBERT LEWIS JR. An outstanding amateur golfer from Northeast Ohio, Mr. Lewis has been a member of four victorious Walker Cup teams (1981, 1983, 1985, and 1987). In 1987 he was low amateur in the Masters and also won the Northeast Ohio Amateur Championship. Mr. Lewis played in seven Masters and three U.S. Opens. In 1982 and 1986 he was on the victorious World Amateur Teams. In 2003, he was captain of the Walker Cup team and inducted into the NOGA Hall of Fame. The photo at left shows Mr. Lewis accepting the NOGA award. (Courtesy Northern Ohio Golf Association.)

MARY ANN BIERMAN. A local golfer and member of the Mayfield Country Club, Mrs. Bierman has competed at all levels: junior girls, amateur, mid-amateur, and senior amateur. Mrs. Bierman grew up in western Pennsylvania where she qualified for the U.S. Junior Girls Championship in 1955 and was a quarter finalist in 1956. She also qualified for the Women's U.S. Open in 1957. Mary Ann won the Western Pennsylvania Women's Championship in 1962 and was runner-up in 1966. Mrs. Bierman has now won the Cleveland Women's Golf Association Championship eleven times, between 1969 and 2004. She was the Women's Club Champion at Mayfield for several years consecutively. She was medalist in the Women's U.S. Mid-Amateur Regional Qualifier in 1990. She qualified for match play in the U.S. Senior Women's Amateur eleven times and has won at various other state and regional tournaments including the 1981 Ohio Women's Amateur and three Ohio Sr. Women's Amateurs. Shown above is Mrs. Bierman putting on the 18th green at Lakewood C.C. where she won the 2004 Cleveland Women's Golf Association Championship.

EIGHT

Golf Exhibitions for Worthy Causes

Elyria C.C., Spring Valley C.C. and the Jack Nicklaus Scholarship Benefit—Golf and Baseball

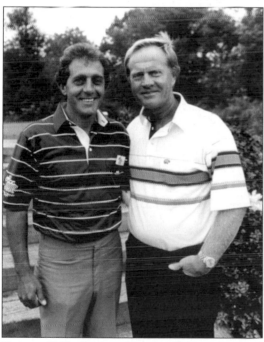 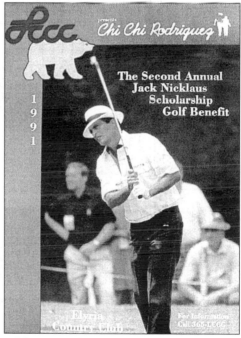

ELYRIA C.C., SPRING VALLEY C.C. AND THE JACK NICKLAUS SCHOLARSHIP BENEFIT. *LEFT:* In 1990 Jack Nicklaus came to Spring Valley C.C. for a golf exhibition to raise money for a Lorain County Community College (LCCC) scholarship fund. This has become an annual event but with different professional golfers playing in the charity event and giving a golf clinic. The fundraiser alternated between Spring Valley and Elyria C.C. for the first several years. There was no event in 1997, but starting in 1998 all events have been held at Elyria C.C. The photo above is Jack Nicklaus with Spring Valley club pro, Mike Caronchi. *RIGHT:* ChiChi Rodriguiz was the guest professional from the PGA Senior Tour at the 1991 Jack Nicklaus Scholarship Golf Benefit. The 1991 event was held at Elyria C.C. Money from the event is to benefit the LCCC Foundation. The poster above is for the 1991 event. (Courtesy of Spring Valley C.C. and the Richard Mellott Collection.)

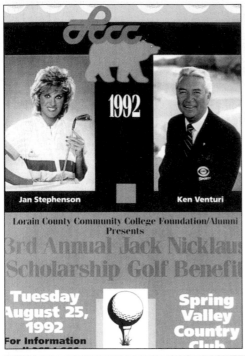

In 1992, the third year for the Jack Nicklaus Scholarship Golf Benefit for LCCC, there were two guest professionals, Jan Stephenson, from the LPGA, and Ken Venturi. Mr. Venturi still has a good golf swing but is primarily a TV golf commentator. Ken Venturi participated in the clinic and Jan Stephenson participated in the golf outing and awards ceremony. Shown at left is the poster advertising the event. (Courtesy of the Richard Mellott Collection.)

Lee Trevino came to Elyria C.C. in 1993 for the Jack Nicklaus Scholarship Golf Benefit. The event is sponsored by the Lorain County Community College Foundation. Lee Trevino won 27 times on the PGA Tour, including two U.S. Opens and two PGA Championships. He also won two British Opens and became one of the winningest players on the senior tour. The special event flag shown above was signed by Mr. Trevino. (Courtesy of the Richard Mellott Collection.)

Greg Norman was the guest professional for the 1994 Jack Nicklaus Scholarship Golf Benefit. Proceeds go to the Lorain County Community College (LCCC). The 1994 event was held at Spring Valley C.C. Shown at right is the poster announcing the event (Courtesy of the Richard Mellott Collection.)

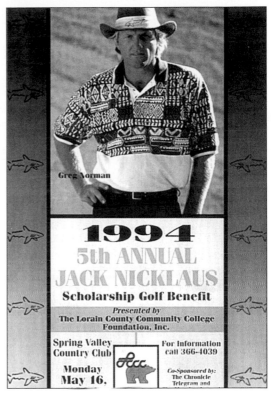

Greg Norman

1994
5th ANNUAL
JACK NICKLAUS
Scholarship Golf Benefit
Presented by
The Lorain County Community College
Foundation, Inc.

Spring Valley
Country Club

For Information
call 366-4039

Monday
May 16,

Co-Sponsored by:
The Chronicle
Telegram and

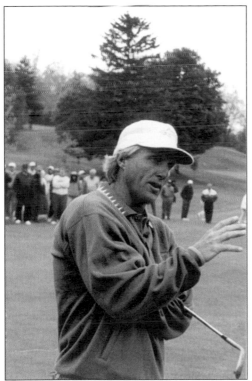

The 1994 LCCC golf benefit was held in May and it was a cold, blustery day. Greg Norman gave the clinic and played in the 18-hole tournament. Greg was very gracious and patient as he answered questions during the clinic. The photo at left shows Mr. Norman explaining a type of shot.

President Roy A. Church of the Lorain County Community College presented an original painting to Greg Norman for Greg's appearance in the 1994 Jack Nicklaus Scholarship Golf Benefit. The painting was done by an outstanding local artist, Lynn Kaatz. The photo above shows the painting being presented. (Courtesy of the Richard Mellott Collection.)

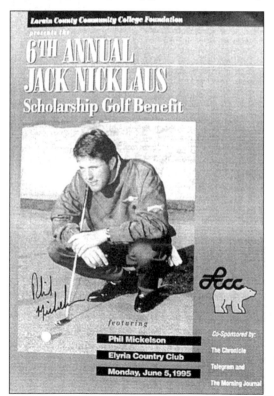

Phil Mickelson was the golf celebrity that participated in the Jack Nicklaus Scholarship Golf Benefit in 1995 at Elyria C.C. Phil has taken 23 PGA tour victories, including an exciting win at the 2004 Masters. The picture at left is the poster for the 1995 event. (Courtesy of the Richard Mellott Collection.)

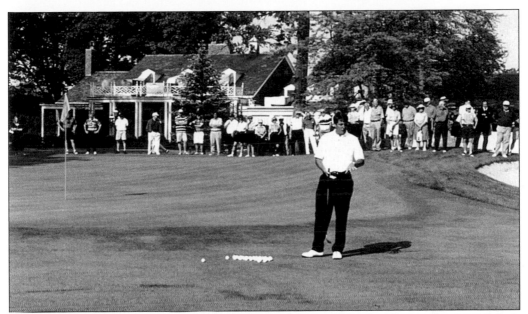

Phil Mickelson demonstrated his short game wizardry for the attendees at the LCCC Jack Nicklaus Scholarship Golf Benefit. The Elyria clubhouse is in the background. (Courtesy of the Richard Mellott Collection.)

The 1996 Jack Nicklaus Scholarship Golf Benefit was held at Elyria C.C. Tom Weiskopf was the guest professional. This was the seventh year for the event. Mr. Weiskopf spoke at the 1996 Jack Nicklaus Scholarship Golf Benefit luncheon. Seated to the right in the photo is Bob Wharton, executive director of the Northern Ohio Golf Association, and Richard Mellott. Mr. Mellott organized the event during the first several years. (Courtesy of the Richard Mellott Collection.)

This author was a golfing participant in the 1996 golf outing sponsored by the Lorain County Community College Foundation. Afterwards Tom Weiskopf was gracious enough to have a picture taken with yours truly.

The 1998 LCCC Golf Benefit included three guests: David Leadbetter, renowned golf teacher; Denis Watson, golf professional and teacher; and Peter Kessler, golf historian and TV host. The three are shown here during the clinic that was a part of the 1998 Jack Nicklaus Scholarship Golf Benefit. (Courtesy of Elyria C.C.)

The guest professionals for the LCCC Jack Nicklaus Scholarship Golf Benefit for 1999 through 2003 were Glen Day, John Mahaffey, Charlie Rymer, and Jack Nicklaus II, Jim Thorpe with Ian Baker-Finch, and Andy Bean with Brad Bryant. Shown at right is the announcement for the Thorpe-Baker-Finch event in 2002. (Courtesy of Elyria C. C.)

GOLF AND BASEBALL. Many baseball players enjoy golf on their days off and in the winter during the off season. The Major League Baseball Players Alumni Association, (MLBPAA) sponsors golf outings for charitable causes. Shown here is a booklet for their 1990 Golf Series. (Courtesy of the MLBPAA.)

117

At the MLBPAA golf outing, baseballs were given to participants to get autographed. This baseball has been signed by several former players, but the autograph shown on top is that of Jimmy Dudley. Mr. Dudley was the "voice" of the Cleveland Indians for many years. He was a very gracious personality.

This old postcard shows the Cleveland Municipal Stadium as it looked for a baseball game. Some retired baseball players became excellent golfers.

118

NINE

LPGA Events

LPGA Events 1974–1976—Shaker Heights C.C. and the World Championship of Women's
Golf—Squaw Creek and Avalon Lakes—LPGA Classics at Avalon Lakes and Squaw Creek

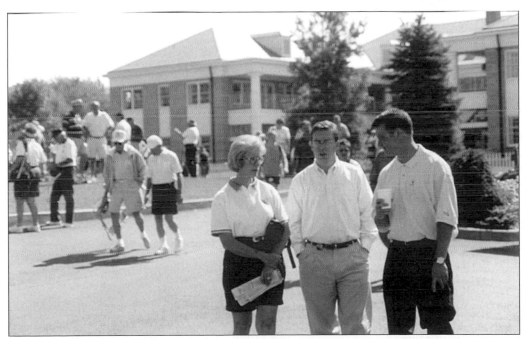

LPGA EVENTS 1974-1976. The Babe Zaharias Invitational Classic was held at Tanglewood
C.C. in 1976. Judy Rankin won this LPGA event with a score of 287 (-1). Jane Blalock came
in second. Patty Berg played at age 58. Earlier, the Lawson's LPGA Classic was hosted by the
Weymouth Valley Course in Medina. Carol Mann won the 1975 tournament with a score of
217 and Judy Rankin was second. Sandra Haynie won the same event in 1974 with a score of
216. The photo above is Judy Rankin several years later at Avalon Lakes. (Courtesy of Giant
Eagle LPGA Classic.)

The World Championship of Women's Golf

UNITED AIRLINES PRO-AM

SHAKER HEIGHTS C.C. AND THE WORLD CHAMPIONSHIP OF WOMEN'S GOLF. Shaker Heights C.C. hosted the 1981–84 World Championships of Women's Golf. These events were limited to a select field of approximately 12 top players. IMG organized the tournament and it was quite successful, but moved to other locations after 1984. The author was fortunate to play in the Pro-Am event all five years. Shown above is the face of a Pro-Am scorecard for 1981. (Courtesy of Shaker Heights C.C.)

The World Championship of Women's Golf

UNITED AIRLINES PRO-AM

Shaker Heights Country Club August 20-23, 1981 Cleveland, Ohio

Beth Daniel won the World Championship of Women's Golf in 1981. She was the defending champion from 1980, when the tournament was played at The Country Club. Her winning score in 1981 was 284. This gave her two in a row. Jan Stephenson was the 1981 runner up at 285. Shown at left is the Waterford Crystal trophy as it appeared on the cover of the 1981 program. The winner received a replica of the trophy plus a 58-piece set of Waterford Crystal. (Courtesy of Shaker Heights C.C.)

The 1982 program for the World Championship of Women's Golf has Beth Daniel on the cover as defending champion, but she finished eleventh after two straight wins in 1980 and 1981. The 1982 winner was JoAnne Carner with a score of 284. Mrs. Carner is affectionately called "Big Mamma" by the other players. She won by five strokes over Ayako Okamoto, who finished second. (Courtesy Shaker Heights C.C.)

The Chevrolet World Championship of Women's Golf

Shaker Heights Country Club, Cleveland • August 16-22, 1982

United Airlines Pro-Am

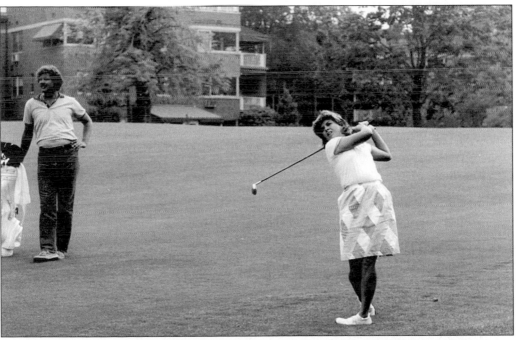

Our Pro-Am partner in 1983 for the World Championship of Women's Golf was Hollis Stacy. She finished in a fifth-place tie the previous year. Hollis took the 1984 U.S. Open for her third U.S. Open victory. She also won three U.S. Girls' Junior titles, making a total of six USGA titles. Hollis is pictured above making a fairway shot in the Pro-Am.

121

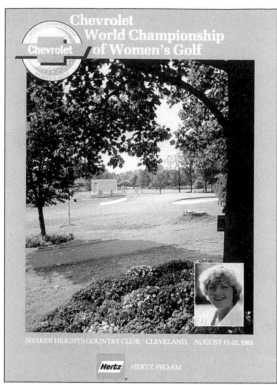

The 1983 program for the World Championship of Women's Golf cover shows a picture of the golf course with an inset photo of JoAnne Carner, the defending champion. She did not disappoint her fans, as she won again for two in a row. Her winning score this time was 282, two better than the previous year. Ayako Okamoto was again the runner-up, two shots back at 284. (Courtesy of Shaker Heights C.C.)

With JoAnne Carner winning the 1982 and 1983 World Championship of Women's Golf, we thought having her on our Pro-Am team for 1984 gave us a good chance to win. She played well, but the amateurs couldn't quite keep up. This photo shows Mrs. Carner playing a shot to the green. She was a pleasure to be around.

Nancy Lopez shown at right won the 1984 World Championship of Women's Golf. Her 281 winning total was the lowest winning score of the four years of the tournament while it was played at Shaker Heights C.C. Nancy had finished second in the inaugural event in 1980 at The Country Club. (Courtesy of Shaker Heights C.C.)

Shown here is the program cover for the 1984 World Championship of Women's Golf. The tournament moved to other locations with other sponsors starting in 1985. The winners of this tournament received the women tours largest paycheck. This international tournament was also the most widely televised event of that year. (Courtesy of Shaker Heights C.C.)

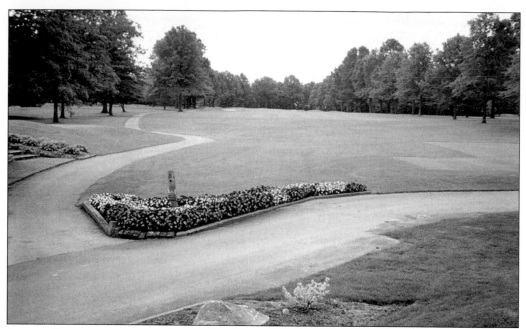

SQUAW CREEK AND AVALON LAKES. The Squaw Creek Golf Course was opened in 1924 and the architect was Stanley Thompson. The Vienna, Ohio course in the Youngstown-Warren area plays to 6,908 yards from the back tees. Stanley Thompson also designed other Northeastern Ohio golf courses: Beechmont, Chagrin Valley, Sleepy Hollow, and Trumbull C.C. A photo of Squaw Creek's 10th hole is shown above. (Courtesy of Avalon Golf & Country Club.)

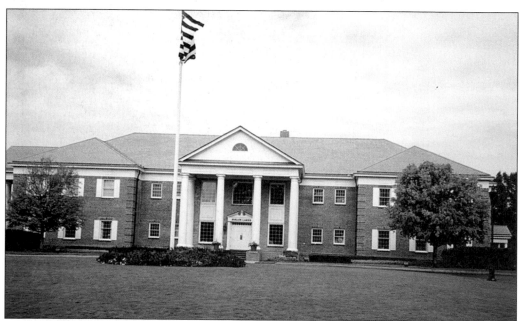

The Avalon Lakes Golf Course is under the same management as its sister course, Squaw Creek. Avalon Lakes is much newer, opening in 1996. Avalon Lakes was designed by Pete Dye and can play as a very long course at 7,551 yards. The Avalon Lakes course is in Warren, Ohio. Its clubhouse is shown above. (Courtesy of Avalon Golf & Country Club.)

The Squaw Creek Golf Course hosted the Phar-Mor in Youngstown, an LPGA tournament, from 1990 to 1992. The winners were Beth Daniel (1990), Deb Richard (1991) and Betsy King (1992). Starting in 1993 a new series of tournaments began at Avalon Lakes. A view of the Squaw Creek Clubhouse is shown above. (Courtesy of Avalon Golf & Country Club.)

LPGA CLASSICS AT AVALON LAKES
AND SQUAW CREEK Avalon Lakes
and Squaw Creek continued to host
an LPGA tournament. From 1993
through 1996 the tournament was
called the Youngstown-Warren
LPGA Classic and was played at the
Avalon Lakes Course. Nancy Lopez
was the 1993 winner and is shown at
right with her caddy. (Courtesy of
Giant Eagle LPGA Classic.)

Michelle McGann won the Youngstown-Warren LPGA Classic in back-to-back years (1995 and 1996). Giant Eagle, the regional grocery chain, became the title sponsor in 1997. The program cover for the 1997 tournament is shown at left, featuring Michelle McGann. (Courtesy of Giant Eagle-LPGA Classic.)

Tammie Green won the 1997 Giant Eagle Classic with a score of 203. She also won in 1994, scoring 206. Both years the Classic was at the Avalon Lakes Course. In 1997, Tammie had to win in a playoff with Laura Davies. It was a sudden death playoff that lasted five holes. Tammie Green, a native of Somerset, Ohio, is shown at right. (Courtesy of Giant Eagle LPGA Classic.)

The 1998–2000 winners of the Giant
Eagle LPGA Classic were Si Ri Pak,
Jackie Gallagher-Smith, and Dorothy
Delasin. Shown at right is the program
cover for the 2001 tournament and all
previous winners since 1993 are pictured
along with the trophy. (Courtesy of
Giant Eagle LPGA Classic.)

The Giant Eagle LPGA Classic shifted
sites to the Squaw Creek course from
2001 through 2004. The winners were
Dorothy Delasin (defending champ),
Mi Hyun Kim, Rachel Teske, and
Moira Dunn. The cover of the 2004
program shows Rachel Teske, the 2003
winner. (Courtesy of Giant Eagle
LPGA Classic.)

BIBLIOGRAPHY

Alliss, Peter. *The Who's Who of Golf*, 1983

Arthur, Allan. *The Country Club-It's First 75 Years*, 1964

Barkow, Al. *The History of the PGA Tour*, 1989

Barkow, Al, et.al. *20th Century Golf Chronicle*, 1998

Bookatz, Barnett, et. al. *The Oakwood Club-75th Anniversary*, 1980

Cornish, Geoffrey S. & Whitten, Ronald E. *The Golf Course*, 1988

Gibson, Nevin H. *The Encyclopedia of Golf*, 1958

Golf Magazine, *Encyclopedia of Golf, Rev.*, 1979

Grabowski, *John J. Sports in Cleveland*, 1992

Greater *Cleveland Golf News*, Vol.7, No. 2, May 2004

Hotchkiss, John F. *500 Years of Golf Balls*, 1997

Johnson, Salvatore. *The Official U. S. Open Almanac*, 1995

Lane, James M. *The Golfer's Almanac*, 1996

Matuz, Roger. *Inside Sports Magazine*, 1997

Mayfield C. C., *75th Anniversary 1911–1986*, 1986

McCormack, Mark H. *The World of Professional Golf*, 1972

NOGA, *Fairways Magazine*, various dates

NOGA, 2004 Directory, 2004

Peper,George. *Golf Courses of the PGA Tour*, 2nd ed., 1994

PGA Tour, Senior PGA Tour Media Guide, 1996

Rose, William Ganson. *Cleveland The Making of a City*, 1950

Seagrave, Alice. *Golf Retold, The Story of Golf in Cleveland*, 1940

Shaker Heights C.C., *Our Diamond Jubilee*, 1988

Steele, Donald & Ryde, Peter. *The Encyclopedia of Golf*, 1975

Tidyman, John H. *Cleveland's Public Golf Courses*, 1992

Tillinghast, A. W. *Reminiscences of the Links*, 1998

USGA, 1995 *Championship Media Guide*, 1995